CHARLES PLATTEN WOODHOUSE
IVORIES

CHARLES PLATTEN WOODHOUSE

IVORIES

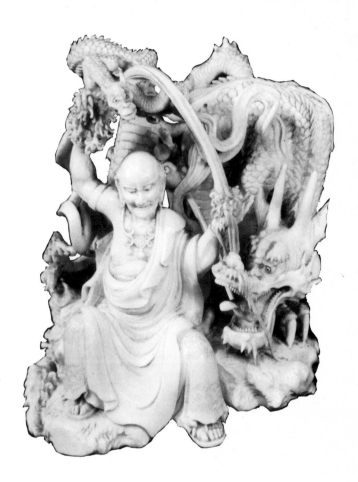

A History and Guide

David & Charles
Newton Abbot London Vancouver

ISBN 0 7153 7043 X

Set in 11 on 12 pt Bembo
and printed in Great Britain
by Redwood Burn Limited
Trowbridge & Esher
for David & Charles (Publishers) Limited
Brunel House Newton Abbot Devon

Published in Canada
by Douglas David & Charles Limited
1875 Welch Street North Vancouver BC

Contents

Foreword

Ivory possesses a unique quality and attraction. It has been prized through the ages in east and west. Gifted artists have created ivories of supreme beauty and universal appeal. From the remote past, whether used in the embellishment of furniture or in the production of ornaments, jewellery, chesspieces etc, ivory has been worked with skill and ingenuity by craftsmen encouraged by the beauty of the material to exercise their utmost talent.

This book has a two-fold purpose: first to give practical guidance to collectors of ivories, with the interests of those with limited amounts to invest particularly in mind, and second to provide interesting reading for non-collectors who admire ivories and wish to know more concerning their origin, history and character.

Besides superb works of art in ivory – 'museum' or 'collectors' items as they are now generally termed – the less remarkable ivories of later date that the novice collector with only a modest amount to spend may still procure are discussed. For example, in Europe generally during the eighteenth century, and later in Victorian England and North America, ivory was extensively used to embellish utilitarian and decorative objects, and also for personal ornaments: ivory jewellery became very popular. Ivories of religious character were produced in large quantity in both the eighteenth and nineteenth centuries. Generally, though ivories, like all *objets d'art*, have greatly appreciated in value, ivories dating from 1800 onwards are still obtainable through diligent search by collectors of moderate or sometimes even less than moderate means. As, through the centuries, innumerable craftsmen carved in ivory whenever the opportunity arose, pieces of widely varying character, often of real charm, are not as rare and elusive as may be imagined. Much depends on sensible searching and sustained enthusiasm in the hunt.

Luck and opportunity are heaven-sent blessings to a collector, but in order to develop expertise, study is of major importance. The novice has to act at the outset with the utmost caution, only purchasing relatively unimportant, though always attractive, ivories that do not necessitate large expenditure. When knowledge increases, and perhaps financial resources also, and taste has had time to mature, it becomes less hazardous to indulge in acquisition at a more elevated level.

It will be noted that the ivories illustrated are principally of

later date, these being considered most likely to interest collectors unable or unwilling to pay the high prices asked for ancient rarities. A few outstanding ivories are shown that collectors desiring to develop sound judgement and good taste are advised to study. Less accomplished ivory carvers emulated the art of masters and were successful in varying degree. As a result, ivories copied from or inspired by prototypes are found ranging from fine or moderately good to extremely inferior examples.

1 Collecting or Enjoying Ivories

The prospective collector who has fallen under the spell of beautiful ivories and has decided to assemble a collection of his own may well find his enthusiasm dampened by well-meaning friends who advise him to turn to collecting in a more plenteous field, where examples can be located with less likelihood of frustration and financial strain. It is true that fine ivories are both somewhat elusive and expensive. It goes without saying that the collector who aims to bring together outstanding examples of the ivory-worker's art, masterpieces that attract world-wide interest on the notable occasions they are offered in salerooms, must be prepared to pay high prices. To own unique and costly examples may become any collector's dream, but for every rare and high-priced ivory that only wealthy collectors or museums with large resources can afford, there are interesting and pleasing examples on the market at comparatively moderate prices. These should meet the aesthetic standards of the collector who must needs be governed by the limits of his pocket.

Indeed, unless he is wealthy a collector of ivories, while constantly endeavouring to cultivate his taste and increase his ability to recognise what is fine, should not ignore the attraction and good workmanship found in objects of less superb quality that are within his means. With ivories, as with practically everything else collected, the character and contents of a collection depend almost as much upon the individual collector's taste as the depth of his purse. In any case he may aim to assemble an interesting general collection, or he may prefer to specialise in pieces of a particular type and period.

Rules for the Hunt

The intuition of a keen collector who follows hunches as to where to look for good specimens that he can afford often develops as his knowledge and perception increase. It will be a waste of time for any but wealthy collectors to attend auctions in the famous salerooms where extremely high prices are now obtained for the finest ivories. Nor will the collector with a modest income expect to procure treasures through knowledgeable dealers who specialise in costly rarities and are in the know as to what may be acquired through negotiation. But since ivory has always been regarded as a precious substance, worthy of the skill of an accomplished craftsman in almost every

9

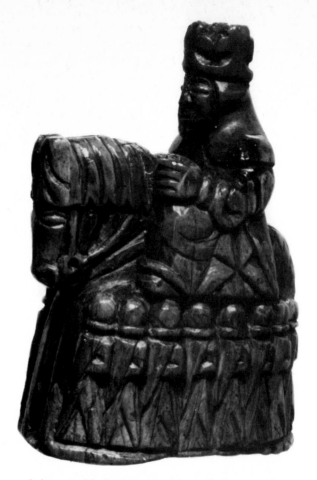

part of the world, large quantities of objects of great diversity have been created for thousands of years. There have been both good and bad craftsmen in ivory at all periods; simple objects of many kinds have poured from humble workshops and splendid works of art have come from the hands of brilliant artists. All manner of ivories greatly varying in quality and character survive.

Ivories have been produced in every part of Europe and North America, Asia, Africa, Greenland, New Zealand, Hawaii and the South Sea Islands. Migrating peoples carried ivories among their most treasured possessions. Ivories taken by emigrants from Europe to America, from Britain to her colonies, or from India to Britain, were accordingly distributed all over the world, particularly during the nineteenth century. In addition to antique ivories taken to all parts of the world by emigrants, the settlers in new lands included skilled ivory workers who practised their craft where they became domiciled.

Clearly then, a collector of ivories has the world for his hunting ground. Any part of any country may unexpectedly

yield finds. It does not necessarily follow that interesting old French ivories may be found at a reasonable price only in France. It chances, for example, that some exceptionally attractive and moderately priced French ivories made at Dieppe in the early eighteenth century were recently offered for sale in Montreal, and might just as likely have been available in New York or Edinburgh. Or further to illustrate the point, during British rule in India large consignments of native carved ivories were shipped to Britain. Ivories were also carried home by British servicemen returning from India; some of these were truly magnificent objects, but a large proportion of Indian ivories that reached Britain during the last century were decidedly inferior. Between extremes we find numerous attractive Indian ivories which, though not in the top collector's class, are excellently carved and of good colour.

Along with Indian and European ivories that found their way into every country in the Old World and were subsequently carried by emigrants to the New World, large amounts of Chinese ivories ended up in the west. In the late nineteenth century the Japanese exported ivory curios to Europe and America although the greater proportion of these were expressly designed to appeal to western tastes and were by and large inferior.

Look and Learn

The most practical approach to collecting ivories successfully is to start with looking and learning. Ivories of all kinds and periods should be studied, by simply gazing at them and, if possible, handling them, before any attempt at purchase is contemplated. Preliminary reading and familiarising oneself with the various types of ivory used by craftsmen are essentials. Books about ivory and ivories are not plentiful, but a number of reliable works published in various countries and languages are listed at the end of this book. Leading fine-art and collectors' magazines often contain authoritative specialist articles on ivories, but as these are usually devoted to more unusual and important objects they may not directly help the novice.

At the outset, museums offer the best and most convenient opportunity for study. As already pointed out, a prospective collector must first familiarise himself with ivories generally. It is very important to know the nature of ivory as a substance in its varying forms and to observe the techniques employed in working it. If examples of the different types of ivory and objects created by craftsmen working in different periods in widely separated localities can be handled, in order to get their 'feel', so much the better. It cannot be overstressed that to touch objects such as ivories, learning the feel of the material, leads to

understanding and appreciation. Ivories need to be handled as often as possible in order to appreciate the art of the ivory worker and to feel the warmth which emanates from a unique material, but if opportunities for this are few, concentrate on practical reading, observation and shrewd thinking, all leading to increasing expertise.

How to Begin

The first questions that arise in the mind of a prospective collector are where and how to begin and what to buy. As ivory has been so popular with carvers at all periods in many countries, pieces of all descriptions turn up almost anywhere, offered for sale privately, on display in antique shops, or even discovered – perhaps mistaken by an untutored auctioneer for bone – in a sale of house contents. A collector will sooner or later realise the advantages of specialisation – of concentrating upon the acquisition of ivories of a particular period, country or style. Specialising in too narrow a range, or in certain types of ivory objects, will inevitably mean protracted and sometimes frustrating search. Any specialisation, of course, leads to increasing discrimination, which inevitably may call for greater expenditure. At the beginning, and indeed continually, a collector of ivories cannot do better than to seek pieces of the best quality that he can afford in a not too restricted range. A miscellaneous but well-chosen collection can in its own way arouse as much interest and admiration as a specialised collection.

Salerooms and the elegant display cabinets of reputable establishments in the great cities of the world will only occasionally offer opportunity for the non-affluent collector. Visits to less pretentious antique and curio shops in town and country are much more likely to prove rewarding.

Of course, there are dealers of high international repute who specialise in buying and selling ivories, men possessed of deep knowledge and who can tell the provenance, quality and market value of most ivories almost at a glance. There are also many dealers in antiques and curios who handle anything and everything, possessing sound working knowledge of antiques and *objets d'art*, but who cannot claim to be experts in more than one or two fields, which may not include ivories. The specialist obviously has much to teach a novice if he can be 'drawn out'. The general dealer may on occasion be able to offer 'finds' – ivories he has obtained by way of trade but understands little about and which he is willing to pass on at a reasonable profit. Specialists usually deal in fine, rare items, but every inexpert collector can benefit from inspecting the stock of a dealer in ivories of the first water.

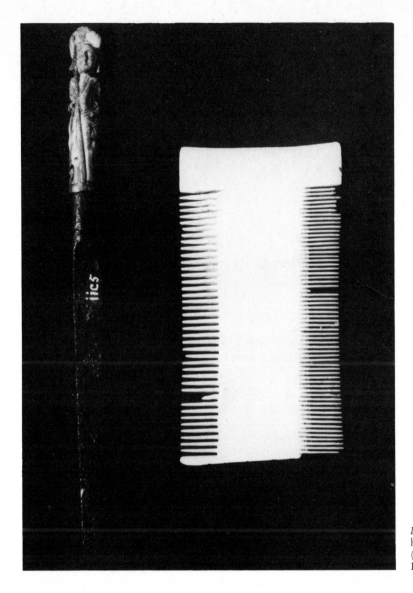

Left: Knife with carved figure handle (c 1480). *Right:* Comb (thirteenth-fourteenth century). Both English.

Know your Dealer; Tell your Friends

An astute collector who can recognise quality and estimate true value has a better chance of securing a prize in the shop where the owner is more concerned with quick turnover and profit and has only limited knowledge of the many different items he handles. In acquiring a bargain, due to his superior knowledge, from a dealer who unwittingly fails to recognise its importance and value, a collector need not be troubled by conscience. A dealer is expected to know the market value of what he sells and if through ignorance or carelessness he sells an article for below

13

its real value the purchaser is not to be blamed for acting upon opportunity. It is only when unscrupulous dealers batten upon too trusting collectors by deliberately foisting inferior or − what is worse − forged items upon them that the situation becomes serious and even dangerous.

A good deal of nonsense has been written concerning wily art and antique dealers, portraying them as unprincipled profiteers and defrauders of the innocent. That a considerable amount of sharp practice goes on is undeniable. By and large, however, as a class of businessmen, antique and art dealers with a care for their reputations are not ruthless scoundrels.

If a collector makes a friend of a trustworthy dealer with extensive contacts amongst other dealers, he has a much stronger chance of eventually obtaining what he seeks. The dealer comes to know the collector's interests precisely and can keep an eye open on his customer's behalf; in this way some excellent fine-art collections have been assembled. It also helps to discuss collecting problems and aspirations with an interested friend. Indeed, let your friends and others know about your collecting interests. There must be many attractive ivories still in private possession whose owners know little of their nature and value. An independent valuation can always be obtained if desired.

It is most satisfactory, perhaps, to know that ivories are being collected simply because they are regarded as beautiful and interesting. However, most collectors will naturally feel concerned that their purchases will at least retain their market value. As with most art objects, values tend to fluctuate from time to time, but taken over the past half century or so ivories have steadily risen in value. It has already been noted that ivories have generally been esteemed as precious objects through the centuries, whether or not owners chanced to be collectors. During the nineteenth century in Europe, when many ivories of inferior workmanship were produced to meet popular demand, a number of discerning collectors formed valuable collections of fine old ivories. In the first half of the present century, however, diminishing interest in ivories and the use of ivory in ornamentation affected the industry and caused depreciation in values. Dealers and collectors moved warily even when important items were offered on the market. Nonetheless, with passing time bringing revival of interest, good quality ivories on the whole have proved a sound investment.

A Rising Market

The purely speculative purchaser who has invested in ivories may rest easy in mind concerning the future state of the market. Since World War II the number of collectors of antiques and

works of art has increased enormously. All kinds of art objects, including ivories, are being sought by a growing army of collectors and investors. As there is naturally no increase in supplies, it appears highly improbable that demand will diminish or values fall. Prices which appear excessive today may well be considered fantastically low within a decade.

A piece of sound advice needs constantly to be kept in mind by all purchasers of ivories, be they collectors or speculators. Always buy the best examples that means will allow and when you can afford even better pieces sell off anything you have that is inferior. Continue to improve the standard of your collection by weeding out. Remember that a buyer can always be found for what is fine if for any reason you are compelled to sell part or all of your collection.

2 The Character of Ivory

Ivory is extremely durable; it will not burn and is virtually unaffected by water. It has been recovered from long-submerged wrecks of ships and found to be only slightly discoloured where the salt water has penetrated a little below the surface. It withstands rough treatment while possessing the practical advantage of a smooth, easily worked surface that is ideal for carving. Moreover, ivory assumes a richer colouring with age and in mellowing acquires even greater beauty. Ivory of the best quality and colour comes from the African elephant. Asian ivory tends to yellow rapidly. Indian ivory is densely white and the easiest to carve.

The word ivory is generally taken to signify the substance composing the tusks (the incisor teeth) of the elephant. There are a number of substances similar in composition and appearance obtained from other animals, including the walrus, hippopotamus, sperm whale, narwhal and wild boar, and also from the seeds of fruit-bearing trees.

Elephant ivory, however, is regarded as 'true' ivory and is the ivory of commerce. In common with the ivory tusks of the ancient mammoth, elephant tusks when cut in section exhibit an easily discernible pattern, formed of curving lines arching in an even arrangement from the centre, producing an effect often likened to engine-turning. Elephant tusks begin their growth as a semi-solid pulp, gathering phosphates and hardening as they lengthen. The tusk is hollow for part of its length, terminating in a rounded point. An elephant's size does not determine the length and thickness of its tusks, which continue growing throughout its lifetime.

In his *Book of Ivory,* G.C. Williamson quoted Sir Richard Owen's definition of ivory published in the Royal Society of Art's journal in 1856. 'Although no other teeth except those of the elephant present the characteristic of true ivory, there are teeth in many species of animals which from their large size and the density of their principal substance, are useful in the arts for purposes analogous to those for which true ivory is used; and some such as those of the large tusks of the hippopotamus, are specially serviceable for certain purposes.' In his observations on the building up of the tusk layer by layer, Owen wrote of its 'being subject to no habitual attrition from an opposed tooth, but being worn only by the occasional uses to which it is applied, it

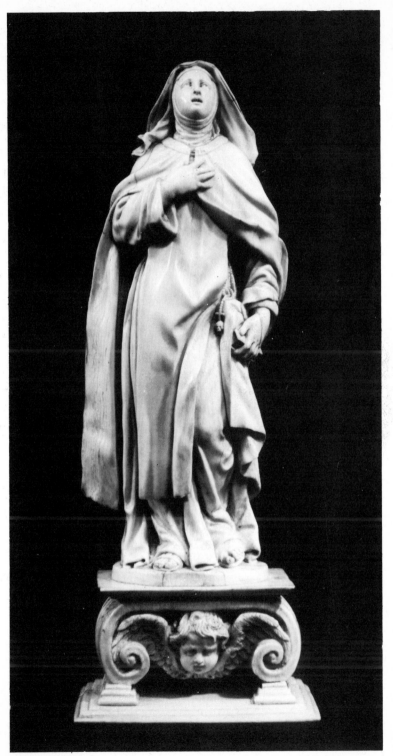

St Teresa of Avila. Probably
Flemish (Late seventeenth cen-
tury).

arrives at an extraordinary length, following the curve originally impressed upon it by the form of the socket, and gradually widening from the projecting apex to that part which was formed when the matrix and the socket had reached their full size.' Approximately one-third of the tusk is embedded in the animal's skull. Concerning the remarkable formation of minute tubes which make up the structure of ivory Owen observed that these tubes 'at their origin from the pulp cavity, do not exceed 1/15,000 of an inch in diameter, in their close arrangement at intervals scarcely exceeding the breadth of a single tube, and above all, in their strong and almost angular gyrations, which are much greater than the secondary curvatures of the tubes of ordinary dentine.'

Williamson also quoted from Professor A. Thomson's *Biology for Everyman* which, written much later than Owen's article, contains a concise, accurate description of the elephant's tusks and how they serve the animal.

The tusks of the elephant are not canines, as tusks usually are, but incisor teeth, whose roots grow back into the maxillae. They are confined to the upper jaw in modern elephants and they consist of ivory only, though there is a patch of enamel at the tip of young teeth. The tusks are used in fighting, but also in digging for roots. The right one seems to be more used than the left, and becomes shorter and lighter. A single tusk has been known to weigh 188 lbs. but the average for left and right is about 75 and 65 lbs. The elephant has no canines or premolars, but the molars are so immense that the jaw cannot hold at one time more than two well-developed teeth and part of a third. When these are lost in the course of an elephant's long life, there are three more to take their place. These huge molars are well suited to grind down the coarse vegetable food, and their worn surface shows successive layers of enamel, dentine and cement. The peculiar pattern is due to the enamel being folded into the ivory. It is interesting to note that the elephant's are the most highly modified of all mammalian teeth.

It may be pointed out here that dentine is formed by calcification of the pulp, cement is formed by calcification of the capule containing the pulp, and enamel is an intermediate substance occasionally present.

Hard and Soft

African elephant ivory consists of two types, a hard ivory usually obtained from animals inhabiting the western half of the continent and a softer variety generally obtained from animals in

the eastern half. Other significant differences are that the softer eastern tusk is pure white in colour, more curved and twisted, and with a blunt point; the harder tusk is not so densely white and is narrower and straighter in shape. The hard tusk tends to be more brittle than the softer tusk. The average length of an African male elephant's tusk is around six feet, and they weigh about fifty pounds each. The tusks of Asiatic elephants are much smaller, averaging about five feet in length and weighing some thirty-five pounds each.

Elephants mainly survive in Africa and India, with dwindling herds in other parts of Asia. The Ceylon elephant was originally introduced into the island from India and is therefore not a separate species. African elephants are the largest, and are easily distinguishable from Indian elephants by their greater size and large flapping ears. Both male and female African elephants have large tusks while those of the male Indian elephant are much smaller and the female frequently possesses none. In Ceylon both male and female elephants are sometimes found without tusks.

Little different in appearance from ivory obtained from freshly-killed animals is the fossilised mammoth and elephant ivory once found in large quantities in remote northern areas of Russia and Alaska. Ivory found embedded in ice in river beds in Russia and along frozen shores on the edge of the Arctic Ocean was for centuries a sought-after commodity esteemed in the east. Much of the fossilised ivory brought out of the frozen wastes of Alaska has been found stained a brilliant turquoise blue, due to contact with minerals. This attractive material is known in the trade as odontolite and has been used in jewellery manufacture as a substitute for turquoise.

Walrus, Hippopotamus, and Whale

The teeth and tusks of other animals, though lacking the superior quality of elephant ivory, have been put to good use by ivory workers through the centuries. Walrus ivory was used by European carvers at least as early as the eleventh century and probably much earlier; it is also known as morse ivory. This large member of the seal family was greatly reduced in number during bygone centuries when it was ruthlessly slaughtered for the sake of its tusks. Both Scandinavian and oriental ivory carvers traded with hunters and merchants who grew rich by supplying a much admired material. The most notable early Scandinavian ivories are nearly all carved from walrus ivory.

Walrus tusks sometimes grow to two feet in length extending downwards from the upper jaw. A tusk may weigh up to eight pounds. The ivory is much less dense than elephant ivory but it is of excellent quality. The principal drawback to walrus ivory in carving is that owing to the tusk being hollow for much of its

length considerable wastage in working is often unavoidable.

In ancient times, especially in Egypt, the long canines and lower incisors of the hippopotamus provided a useful substitute when elephant ivory was scarce. Because hippopotamus ivory is harder, and because it is necessary to remove the outer casing of enamel from the long tusk-like canines to reach the ivory, ancient craftsmen probably refrained from using it while elephant tusks were available. But because of its hardness it was long used in making dentures, for example in ancient Rome. The curvature of the canine tooth of the hippopotamus is very definite — much more than that of an elephant tusk. Continuous abrasion due to contact with opposing teeth causes both the canines and incisors of the hippopotamus to be sharply pointed at the ends. In contrast with the pronounced curvature of the canines, the incisors of the hippopotamus are straight; but being mostly hollow the amount of solid ivory obtainable from them is relatively small. The crisscross lines characteristic of elephant ivory are absent. Hippopotamus teeth are sometimes referred to in Japan as 'dolphin's teeth' and have been extensively used by Japanese ivory craftsmen in the production of small carved objects. The Japanese admire the fine grain and dense whiteness, and used it during the nineteenth and early twentieth centuries for carved *netsukes* (see p97) made expressly for the tourist and export trade. The workers steep hippopotamus teeth in acid to remove the enamel casing, although the process often damages the ivory beneath.

One differing characteristic of elephant and hippopotamus ivory is that when the former becomes extremely old, as seen in ivories removed from ancient tombs, the component layers of thin cones or tubes sometimes display a tendency to separate, whereas ancient hippopotamus ivory taken from tombs will occasionally be found to be in process of disintegrating in longitudinal splits and transverse cracks, finally breaking into long pieces.

Ivory is obtained from both the sperm whale and the narwhal. The lower jaw of the sperm whale contains from forty to fifty teeth relatively small in size and therefore offering only limited scope to ivory workers. The single large tusk of the male narwhal, a rarely seen species of whale found in the Arctic, is of no great commercial interest. It possesses only two teeth, of which the left one develops into a cylindrical ivory tusk sometimes reaching eight feet in length. It has an excellent colour and has a fine surface for carving, but the tusk has a deep cavity and spiral groove that extends along its entire length, which renders the material difficult to work. Until World War II narwhal ivory was used extensively by Japanese ivory workers in the production of rings, carved figurines, curios and *netsukes,* but

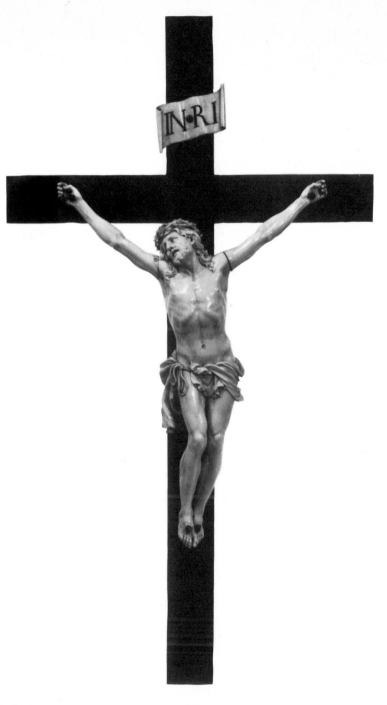

Crucifix of ivory and ebony;
Flemish or German (seventeenth
century).

elsewhere in the world it has never been highly valued or widely used.

The horny *epithema* of the helmeted hornbill, a curious bird native to Indonesia, yields a substance often used by Chinese carvers as a substitute for true ivory. The hard, dense material lends itself admirably to the carving techniques of Chinese ivory workers and beautiful small personal ornaments have been created.

Vegetable Ivory

Seeds obtained from the fruit of a species of palm tree known as *Phytelephas macrocarpa,* indigenous to the Andes region extending along the western coast of South America, yield a substitute for true ivory. Baron Alexander von Humboldt, the intrepid German naturalist and traveller, first observed the trees growing in the Andes valleys during his journey through the region at the beginning of the nineteenth century. Humboldt was responsible for the shipment of the first cargo of so-called corozo nuts to Europe and a considerable trade subsequently developed.

Each dwarf palm tree produces six or seven large globular fruit, weighing up to twenty-five pounds each and containing the nuts. The vegetable ivory is obtained by removing the inner white lining or albumen of the nut or seed case. While the seed-head is ripening it contains a milk-like fluid which gradually hardens and assumes the appearance of ivory.

Ivory workers in England began using vegetable ivory during the early decades of the nineteenth century. Objects carved from it were exhibited in the Great Exhibition of 1851. Its failure to win great popularity may have been because of its cold whiteness which did not appeal to Victorian taste.

Vegetable ivory obtained from corozo nuts began to be used by Japanese ivory carvers in the nineteenth century and has found limited favour in Japan in more recent times. Unlike western craftsmen, who chiefly used vegetable ivory for utilitarian objects, including buttons, Japanese workers created a variety of *netsukes* and diminutive ornaments from it. A type of vegetable ivory derived from a species of palm is called *binroji* in Japan. It is stained to simulate mellow old ivory and objects fashioned from it by clever craftsmen can be deceptive indeed.

3 Ivory in Antiquity

Ivory has been worked by man since prehistoric times. In all the great civilisations ivory carving has rated high as an artistic accomplishment. The material itself is valued and admired almost as much for its natural beauty as for the increased attraction it gains when, in the hands of a skilled craftsman, it is carved into a precious object. Primitive man was limited in his power to exploit the qualities of the material but even at a very remote period he was not insensitive to its beauty. Some of the oldest known carved objects made from mammoth ivory, probably some 20,000 years old, were recovered from caves in south-western France once inhabited by prehistoric tribes. From ancient artifacts found in various parts of Europe and Asia it appears that primitive man developed considerable ability in working ivory. Beads carved from mammoth ivory were discovered near Les Eyzies in France and in Etruscan tombs in Italy. Carved ivory objects found in Spain resemble others unearthed in the Greek islands that are thought to date from the Minoan period. Ivories brought to light on excavated sites widely separated by land and water, including the ruins of Nineveh, ancient Japanese tombs and buried Chinese cities, also objects found in Russia, prove that ivory was worked by many races over a wide area at a very early period.

Ivories of Ancient Egypt

The ancient Egyptians were undoubtedly among the earliest civilised people to appreciate the unique qualities of ivory and to establish workshops where groups of craftsmen were employed. Ivory objects were produced exclusively for the pharaoh and wealthy nobility. Among the earliest Egyptian ivories known are a number of diminutive carved figurines, each about two inches high and believed to be votive offerings. These are now in the Walters Art Gallery, Baltimore. Ivories in great variety were found among the large number of artifacts recovered from excavated Egyptian graves at Nagadah during operations conducted on the site through the first two decades of the twentieth century. These are considered to be much older than the Baltimore statuettes and could possibly date from as early as ten centuries before the Christian era.

Owing to ancient Egyptian styles in art remaining virtually unchanged through many centuries, with the same type of

materials in use during successive dynasties, correct attribution of ancient Egyptian artifacts is sometimes difficult. In the case of ivories removed from the tombs of pharaohs and others it has been comparatively easy to date pieces as most objects placed in the tomb were made during the lifetime of the deceased, or at the time of his death as mortuary furnishings. Uncertainty occurs on occasion when an Egyptian ivory turns up and neither the tomb from which it came nor its subsequent ownership is known. The age of ivories can be approximately arrived at by careful study of the substance, observing the effects of time, exposure to light or burial upon the objects, but errors of judgement can occur even when tests are carried out, and experts will disagree on questions of age and provenance.

Study of ancient Egyptian ivories reveals the extent to which the material was valued by craftsmen who obviously found pleasure in handling it. Furniture embellishment and the production of a large variety of utilitarian and ornamental articles were carried out with originality and artistry. Egyptian tombs have yielded carved statuettes made from complete tusks, exquisitely carved ivory combs, hairpins, spoons, vases, and magnificent jewellery in which ivory is incorporated, often set with gems. Representations of animals, birds and fish were much favoured in the decoration of mirror handles. Odd pieces of ivory, the wastage from other works, were utilised for inlaying caskets and furniture. The technique of carving ivory in relief probably developed in Egypt after about 3000 BC.

Most astonishing, and captivating in their beauty, were the ivory objects discovered in Tutankhamen's tomb in 1922. A magnificent solid ivory jewel-casket with the hinges, knobs and feet encased in gold is one of the most superb objects of its kind ever recovered from an ancient Egyptian tomb. The front of the casket is carved with the boy pharaoh's Horus name, prenomen and nomen. Another casket recovered from the tomb, made to contain treasure, is ornamented with ivory and ebony veneer marquetry and demonstrates the Egyptian inlay technique. Apparently, after carefully smoothing the surface of the wooden carcase the craftsman completely covered it with adhesive, then proceeded to lay the pieces in place. Some 45,000 pieces were used in the decoration of the casket, which bears an inscription signifying that it held 'the jewels and gold of the procession made in the bedchamber'.

Howard Carter's authoritative work on the contents of Tutankhamen's tomb drew attention to a bowl made from a solid chunk of ivory. The bowl measures $6\frac{1}{2}$ inches in diameter and indicates the remarkable thickness of elephant tusks procurable in Egypt at that period.

Among the multifarious Egyptian ivories now preserved in

The Four Seasons, carved in walnut and ivory; south German (early eighteenth century).

collections throughout the world, including palettes, toilet articles, caskets, gaming pieces, figures, plaques, seals, spoons, to name but a few, none are more fascinating than the innumerable carved images of deities, royal and noble personages, animals, birds and reptiles made in amazing variety from the beginning of Egyptian civilisation to the end of pharaonic rule. Whether it be an ivory male figure from a pre-dynastic grave opened at El Mahasna, an Amarna figure of a grasshopper with movable wings concealing kohl for use at the dressing-table, or a pharaoh of the first dynasty wearing the crown of Upper Egypt and an elaborately embroidered robe, all exhibit the same powerful realism in execution.

The Egyptian sculptor in ivory had not only to master the techniques of preparing and working ivory in the ordinary way, but in addition, when it came to portraiture, in order to please his patron he had to produce a good likeness according to the prevailing style of the time. Egyptians worked elephant or hippopotamus ivory with equal skill, the latter being extensively used during earlier dynasties. Perhaps the grace and charm of some simple pieces not intended as works of art stem from the ancient Egyptian craftsman's reverence for his material.

The Phoenicians were less vitally concerned with the attraction of ivory as a sculptor's medium than with its commercial potential. They established an ivory trade that extended into Europe. Ivory was chiefly obtained from Africa and Syria, but according to ancient tradition, the Phoenicians

25

procured supplies of elephant ivory from India. Phoenician craftsmen specialised in the production of ivory ornaments and used the material for elaborate furniture inlay. Ivory used on furniture was often encrusted with lapis lazuli and gold, or overpainted in brilliant colours. Gilding was sometimes so lavish that little of the ivory surface was left uncovered. It now appears feasible that the remarkable group of ivories unearthed at Nimrud and now in the British Museum, many inlaid with lapis lazuli and gold, may, despite obvious Egyptian influences on style, have been the work of Phoenician craftsmen. Many Phoenician artists settled in Babylonia between the ninth and seventh centuries BC to which period the Nimrud ivories are assigned. Almost certainly the Phoenicians learned the techniques of ivory carving from the Egyptians.

In Ancient Greece

Surviving examples of ancient Greek art in ivory are regrettably few. A striking figure of an acrobat found at Knossos in Crete, now in the museum at Candia, is considered to be one of the most superb examples. Homer's references to ivory leads to the supposition that the material was employed decoratively in Greek houses in his time. We learn from the *Odyssey* that it was used for both utilitarian and ornamental purposes at the home of Menelaus at Sparta, where one of the 'gates of dreams' was made of ivory.

Among Minoan art treasures preserved in modern collections scarcely any object is more arresting than the renowned ivory 'snake goddess' figure now at Boston. A gaming box with low relief carving in traditional early Greek classical style, found at Enkomi in Cyprus, seems either to indicate that the mainland Greeks exported ivories or that their techniques were imitated on adjacent islands. A number of ivories found in mainland Greece on sites at Mycenae and Sparta exhibit strong Asian influence. These are thought to have come from Asia Minor where they were probably carved by Greek colonists.

The traditions of Greek ivory sculpture were probably well established by the beginning of the Geometric period (1000 – 750 BC). In the Greek colonies in Italy and along the fringe of Africa a traditional style in ivory carving was principally associated with the production of statuettes, usually female figures of votive character. Excavation in the ruined sanctuary of Artemis Orthia in Sparta brought to light a number of ivory votive statuettes and groups, including a group of seated women and animals carved in the round. These are assigned to the period between the eighth and seventh centuries BC.

Although the classical Greek style in ivory carving continued into the Hellenistic era, new techniques and increasing Asian

stylistic influences brought gradual changes. Previously, during the period extending approximately from the ninth to sixth centuries BC, both Asian and Egyptian influences predominated in Greek sculptural art, as discernible in surviving ivories from Rhodes and Ephesus, and also in ivories of Greek workmanship found in Spain and Italy. Some interesting examples of foreign influences on style in Greek ivory sculpture may be seen in Athens Museum.

Hellenistic ivories were skilfully and sensitively executed. Although early Greek ivories are generally regarded as the finest, the productions of later periods, particularly of early Hellenistic times, leave no doubt that ivory continued popular in Greece until the Roman conquest.

Nothing has survived of the extraordinary chryselephantine (gold and ivory) works of the great Greek sculptors, including the celebrated statues created by Phidias, a master of the technique. Phidias's colossal chryselephantine figures of Zeus at Olympus and Athena in the Parthenon were probably the most magnificent works of their kind to appear in ancient Greece. It is believed that Kiolotes, a pupil, collaborated with Phidias in the creation of the Zeus statue. It is not known where or how the technique of overlaying with gold and ivory originated or who besides Phidias among Greek sculptors specialised in such work, excepting Polycleitus, creator of the great statue of Hera in the temple at Argos. We know from descriptions in ancient writings that a number of large chryselephantine statues were erected in Greece, including notable examples at Mycenae, Aegina and Corinth.

Ivory was usually painted by the Greeks after the manner of the Phoenicians and Assyrians, but again drawing conclusions from ancient literature it is believed by some authorities that the ivory used on Phidias's giant statues was left uncoloured. A long-accepted theory that the ancient Greek sculptors producing chryselephantine works devised a technique which enabled them to cover large surface areas with ivory previously subjected to softening and flattening is open to question. Dr O. Beigbeder, a leading French authority on ivories, inclines to a theory that large expanses of ivory were created by dowelling small pieces together, a technique also used in marble by early Greek sculptors.

The colossal gold and ivory statues of Zeus and Athena were covered by riveting sheets of the precious metal and ivory to a wood or metal base. Materials were rendered sufficiently thin to bend in shaping. Ivory does not join closely enough to eliminate lines that grow darker and more distinct with passing time, but the statues were usually inspected at a distance sufficient to make these scarcely noticeable. The faces of the great statues were

probably fashioned from pieces of ivory of exceptional width cut from the centre part of an enormous elephant tusk partly sawn through. The pieces were possibly opened out flat after softening by soaking in oil.

Rome: republic and empire

Ivory became extremely popular in Rome as the wealth of the citizens increased. Before Roman ivory workers established workshops ivories were imported from Egypt, Phoenicia and Greece. In a short time, by emulating foreign techniques, Roman ivory workers became very proficient. Pliny the elder commented on the popularity of ivory among the Romans and noted a growing scarcity of elephant ivory in his day. Pliny also made interesting reference to India as a source of supply of the raw material.

Roman furniture was richly embellished with ivory. It was also used decoratively in other ways in the homes of wealthy Romans. Examples of the finely carved ivory plaques which

Tankard, showing Lot and his daughters, signed by the master 'B G'. German or Dutch (late seventeenth century).

were used as ornamentation on Roman furniture may be seen in the Villa Giulia in Rome. Among the objects carved from ivory that fashionable ladies kept in their bedrooms were the beautiful jewel boxes of the pyx type, finely carved with small reliefs in the classical style. A pyx was regarded as a precious object long after the disintegration of the Roman empire, such boxes continuing to be used by upper-class European women at least until the end of the Middle Ages.

Ivory was occasionally used on the outside of Roman public buildings. Propertius mentions the ivory doors of the Temple of Apollo constructed on the Palatine at the instigation of Augustus. They were carved with scenes depicting the slaughter of the children of Niobe and the flight of the Celts from Delphi.

Of major importance among surviving ancient ivories from the Roman era are the series of finely executed so-called 'consular diptychs' of which some fifty examples, either complete or divided in parts, are known. The Roman ivory diptych, of which the consular diptychs are an early type, consisted of double plaques or leaves joined together by hinges, with the inner surfaces coated with wax for use as writing tablets. Consular diptychs appeared during the period AD 400 - 541 when newly-appointed consuls would present them to the emperor and important officials, and perhaps friends, on the occasion of their investiture. Surviving examples are dated between AD 410 and 541, the office of consul being abolished by Justinian in the latter year. Consular diptychs usually carry the name and a half-length portrait of the consul seated in his chair of office. It is not often difficult to date Roman consular diptychs but usually their place of origin remains obscure. Some fine examples in an excellent state of preservation are believed to be of Roman workmanship while others appear to be the work of ivory carvers in Constantinople or Egypt. A number of important collections contain portions of these diptychs which have been divided up – accidentally or deliberately.

Other types of diptychs included the five-leaf 'imperial' diptych, often depicting an emperor vanquishing his enemies in battle or alternatively a 'triumph' march. Diptychs were also created to mark important family occasions, particularly marriages.

After the collapse of the western empire many Roman consular diptychs passed to churches and religious establishments. Saints' and bishops' names were substituted for those of consuls, and with scarcely any alteration the diptychs found a place with treasures of Christian art.

Collecting Ancient Ivories

Most collectors cannot hope to procure exceedingly ancient

ivories. Rarity and antiquity largely govern the values of ivories and on the infrequent occasions when ancient Egyptian, Greek or Roman items are offered for sale their price will inevitably be high. The majority of such coveted rarities as are known have been gathered into important public and private collections.

Ivories yet to be unearthed on ancient sites now being excavated will be at the disposal of the authorities of the country where found, or by the institution or body responsible for the dig. Archaeological finds nowadays usually pass into public collections and are not offered for sale.

Authentic ivories of great age and beauty are extremely valuable. Fraud in antiquities and works of art is a persistent evil. Any collector offered for the proverbial 'song' an ivory that his commonsense tells him is worth a great deal more should check and double check.

4 Early European Ivories

Only a comparatively small number of ivories produced in Europe before the Renaissance have survived, but they are important in the study of western art in ivory. As Christianity spread across Europe from Rome, art styles continuously changed. For a long period Christian art showed a strong Byzantine influence. In the ultimate development of Romanesque art the style clearly incorporated Byzantine elements, though perhaps not to the extent sometimes suggested. In a number of important centres where ivories were produced from the fourth to sixth centuries, particularly the flourishing workshops at Constantinople, Alexandria and Rome, artists were trained in carving techniques and later settled elsewhere, introducing their craft and new styles into more remote parts of Europe.

It is known that Byzantine carvers produced quantities of richly carved ivories though practically all have vanished. The fact that not a single Byzantine ivory dating from the seventh to ninth centuries is known to survive may presumably be due to the Iconoclastic Controversy (706-843) when artists worked under an imperial interdict. In the tenth century conditions for creative artists were very different. Workers engaged in the embellishment of the Great Palace at Constantinople were responsible for fine ornamental work that carried Byzantine art in ivory to its peak of technical and aesthetic excellence.

Early Italian Ivories

Though for the most part free from the more bizarre elements of Byzantine style, early Italian ivories reveal considerable near-Eastern influence in concept. Italians inherited the Roman passion for ivory. By the fourth century some of the workshops active in many parts of Italy were producing ivories comparable with examples produced in Greece at the zenith of Hellenistic achievement. The Italian standard of workmanship continued high even after the collapse of the Roman empire.

Some of the finest Italian ivories executed in Gothic taste came from the workshops of Venice, Pisa and Naples. A superb, albeit restored, statuette in the Gothic style is the Virgin and Child by Giovanni Pisano (c1249-c1314), now in Pisa Cathedral.

The best known group of ivory workers celebrated for fine and original work is the school of Embriachi that flourished in northern Italy in the early fifteenth century. Baldassare deglis

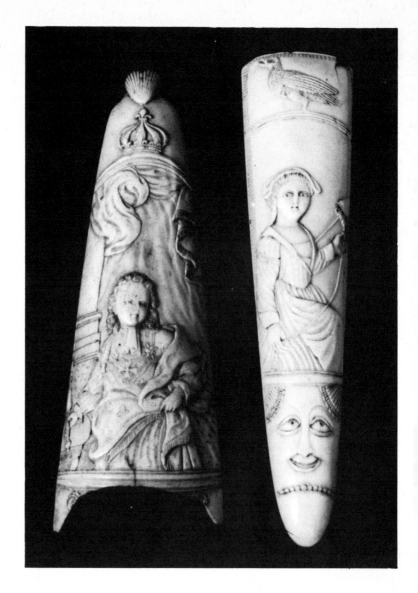

Embriachi's workshop produced ivory jewel caskets, combs,
diptychs, triptychs, altarpieces and other secular and religious
objects. Both mythological and Christian subjects were depicted
in carving, which was generally executed in a 'debased Gothic'
style; patrons included the powerful Visconti of Milan. When in
1431 Embriachi's sons Giovanni and Antonio inherited the
workshop they continued the same traditions. Some of their
monumental works, particularly altarpieces, lacked the brilliant
execution of their less imposing ivory sculpture. The Embriachi
also specialised in carved reliefs enclosed in decorated wooden
frames. In ornamental work they made extensive use of certosina,

an intricate arrangement of geometric inlay composed of bone, elephant and hippopotamus ivory, exotic woods and mother-of-pearl.

Italy became noted for the production of beautiful ivories during the fourteenth and fifteenth centuries when, in addition to the important schools active in the major cities, a number of small workshops away from urban centres turned out objects of excellent quality. Many unpretentious workshops were conducted by skilled craftsmen who had been taught the techniques of ivory carving in one of the celebrated schools. Such establishments followed rather than influenced style and often specialised in the production of objects for secular use including caskets, mirror cases, writing tables, knife and dagger handles, gaming pieces and ornaments. Carving even on small articles was frequently lavish and executed with close attention to detail, especially carving on caskets and mirror cases which often depicted scenes of courtly love or mythological romance.

Writers on the history of ivories have commented on the strange fact that with the birth of the Renaissance, production of works of art in ivory in Italy declined and finally practically ceased. Ivory remained popular in Italy for furniture inlay, and workshops continued to turn out utilitarian and ornamental household articles, but as the Renaissance gained impetus the majority of Italian artists turned to other media.

Germany: Charlemagne and after

With the reign of Charlemagne (768-8l4), European civilisation entered a decisive period in its cultural development. In a short time the art of ivory carving in Germany reached a peak of achievement never before attained in any country that did not border the Mediterranean. Charlemagne's court at Aachen soon became a leading art centre for northern Europe, artists being kept busy in the important workshops set up to accommodate the large influx of craftsmen into the new imperial capital. It may have been Charlemagne's desire to revive Roman culture in his empire. Early Carolingian art styles evolved from a curious blending of Roman, Late Antique and Byzantine elements, but a distinctive style subsequently developed not associated with southern tradition. The influence of early Christian art upon the evolution of the Carolingian style is evident, for example, in the character of ivory diptychs and triptychs.

The beautiful carved ivory panels now in the Louvre depicting David and St Jerome, executed in the so-called court style, are believed to be the earliest examples of Carolingian ivory work in existence. A clue to their date lies in the fact that the panels were originally the cover of a psalter written by Dagulf that Charlemagne presented to Pope Hadrian I (772-795).

From the few examples of Carolingian ivory carving that survive it is apparent that the various German schools and workshops of the period adopted a more or less conventional style and practised the same techniques. Craftsmen probably moved from one workshop or art centre to another, thus transmitting knowledge of processes and introducing new designs. In its beginnings Carolingian ornamental design was strongly inspired by the Late Antique, but with flat decorative patterns of fundamentally northern character included.

The Liuthard Group in Reims adhered to the accepted basic principle of simplicity in form, but their works display a tendency towards roundness and softness in contours. The court style became more graceful under their influence. Creative activity in the fine arts at Reims was largely due to the patronage and encouragement of one man: the former royal serf Ebbo, who directed the imperial library at Aachen before he became Archbishop of Reims in 816. Soon after his arrival in Reims he ordered workshops to be set up that eventually became noted for fine metalwork and wood and ivory carving. As time advanced, the ivory carving of the Reims school developed very distinctive characteristics, with less formal rigidity in the figures and increasing breadth in pictorial representation.

At Metz, ivory carvers respected tradition while developing the court style in their individual way. Outstanding work was done here under the patronage of Archbishop Drago (826-855), an illegitimate son of Charlemagne appointed papal legate.

The school of ivory carvers at Cologne was remarkably productive, but the stylised, somewhat monumental, productions lacked vivacity and were too repetitive in subject. Standards of execution varied at the period, being generally inferior to those maintained in other leading schools. It appears that craftsmen in the prosperous Cologne ivory-carving workshops concentrated on achieving a substantial output which sometimes resulted in careless workmanship.

The school enjoyed high repute, however, and the ivory reliquaries, usually architectural in form, were splendid objects, impressive in their monumental proportions and elaborate embellishment. Ornamentation in relief on reliquaries, though as much favoured at Cologne as at Reims, was not of the same consistently high quality.

Under the first emperor of the German-Italian Holy Roman Empire, Otto I (936-973), the vitality and breadth of earlier Carolingian art was lacking. In its full flowering, Carolingian art became free and expressive, breaking with the lingering formal traditions of early Christian art. Ottonian artists returned to formality and heaviness, undoubtedly influenced by the authority of the Church.

Ivory carving reached its greatest popularity under the Ottonian emperors during the eleventh century when important schools became active within the empire. It is interesting to observe how styles were emulated and sometimes modified by schools situated in different regions. At Cologne, Minden, Liège, Wurzburg and Mainz, artists specialised in low relief carving inspired by Byzantine art. Monastic schools, where some of the most accomplished ivory carvers worked, favoured Carolingian tradition. A continuous change in techniques and style may be noted, but this was little more than superficial. Artists must sometimes have longed to break with convention and introduce more animation and breadth of vision; but under the authority of the Church tradition and convention could not be flouted. Towards the end of the eleventh century sculptors imparted even greater solidity to the appearance of figures and groups, with increasing length as they became more pronouncedly vertical.

With the decline of French ivory-carving centres, the German schools became increasingly productive. Schools at Reichenau and Bamberg led the movement away from universal preoccupation with religious art, but it was a long time before ivories produced for church or private devotional use ceased to constitute the largest proportion of German production. Liturgical combs and knives, bookbindings, small buckets, portable altars and panels richly carved with devotional and coronation scenes were among items produced. Magnificent ivory altarpieces were carved by celebrated sculptors associated with important schools.

Not many early German works of art in ivory have survived, despite the fact that ivory workers were very active in urban centres where ambitious building projects were undertaken. Innumerable secular ivories for ornamental and personal use must have been produced in German workshops throughout and following the Carolingian period, but it is to ivories of religious character that we must turn to study the achievements of carvers in the German schools. As the Gothic style rose to ascendancy in western Europe, Cologne probably became the most active and influential school where religious and secular ivories were produced almost on a commercial scale.

Carved ivory writing tablets displaying a high standard of workmanship, many embellished with paintings and inscribed with prayers, are assigned to South Germany, attesting to the existence of ivory workshops in an area distant from the Moselle and Rhineland regions. In the south the influence of prominent German schools was probably only slight. Having regard to the centuries-old tradition of carving in southern Germany, ivory may well have been carved in the region at a very early period, probably on an extensive scale. The proximity of the area to

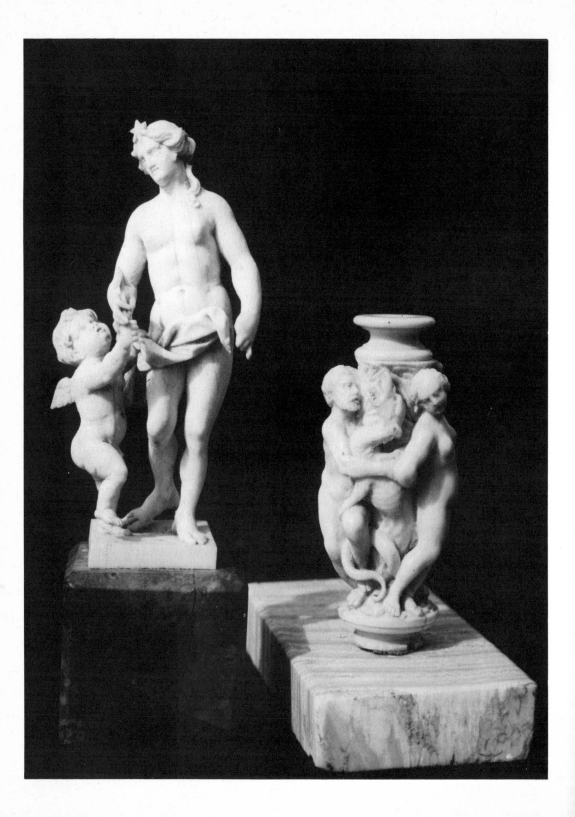

northern Italy, where the tradition had continued since Roman times, leaves little room to doubt that it was from Italy the Germans derived their techniques. In the seventeenth century, when German interest in ivory carving revived, carvers in South Germany became very active. The Odenwald region has an ancient tradition of ivory carving, and craftsmen in the area still produce ivory jewellery, inlaid objects and carved animal figures. It is feasible that a localised art tradition is rooted deep in the remote past.

France: a slower development

In France, ivory carving attained full artistic development somewhat later than in Germany. Production centred in and around Paris, which became the most important city in France where people concerned with the arts foregathered. In the eleventh century production of French ivories rose to an unprecedented level both in quantity and quality. Spurred on by the demand for works of art of all kinds, artists and craftsmen gradually moved away from the monasteries where they had long found employment and established prosperous workshops in Paris. The school of Paris attracted numerous brilliant artists and craftsmen to the Ile de France, which became one of the great art production centres of Europe. Parisian ivory carvers enjoyed the highest repute and the quality of their work eventually surpassed that of the Rhineland ivory carvers. Paris remained pre-eminent in the production of fine ivories until the Gothic tide swept across France. As plans to erect new cathedrals got under way, ivory workers in Paris faced an unexpected situation: the builders showed no interest in beautifying the interiors of their majestic edifices with ivory carvings. However, a new market appeared, occasioned by the demand for altarpieces, diptychs and triptychs for the furnishing of private chapels. Paris workshops were kept busy supplying ivories to the nobility, mostly for religious use but also for domestic ornamentation and for personal use.

With the full flood of Gothic art at the end of the thirteenth century the ivory workshops of Paris began losing their pre-eminence. In the following century the art of ivory carving in France entered a long period of decline.

Ivories in England

Across the English Channel the Anglo-Saxon ivory carvers found new impetus in production after the monastic reforms of the tenth century. While the early Anglo-Saxon style obviously developed from a combination of design elements from the Continental schools, particularly Aachen and Metz, it underwent modification and subsequently became distinctive. A number of important ivory-carving centres arose, the two most notable

being the Canterbury and Winchester schools. A productive school existed at St Albans and less prominent workshops were attached to other cathedral and monastic establishments.

For centuries ivory carvers in England fashioned beautiful small objects from the teeth of whales and porpoises, but the art of carving true ivory had probably not developed until late Anglo-Saxon times. Techniques employed and the high artistic excellence apparent in surviving Anglo-Saxon ivories suggest that even before the monastic reforms, after which arts and crafts appear to have been much more widely pursued in England, ivory workers achieved considerable proficiency. Indeed, some of the late tenth and early eleventh-century work done at Winchester and Canterbury, or in other workshops that emulated their style, is very fine, showing a skill only acquired through long practice. Possibly, of course, continental craftsmen, taught to carve ivory in one of the Rhineland or French schools, crossed to England and found employment in monastic workshops. It is significant that the Carolingian style continued to influence English art during the twelfth century, when some of the finest ivory carving produced in western Europe was executed in English monastic workshops. One of the finest ivory objects of English workmanship, now in the Victoria and Albert Museum, is the richly carved head of a pastoral staff depicting the Nativity and the Annunciation to the Shepherds on one side and an episode from the life of St Nicholas on the other.

In the early Gothic period ivory carvers in England appear to have been actively engaged in the production of religious works for the Church. Reliefs and other objects belonging to the period have a somewhat rigid appearance, without the grace and elegance of French early Gothic ivories, or the refinement and sensitivity associated with English twelfth-century works. In France for a time the advent of Gothicism inspired ivory carvers and led to intensified activity in the production of diptychs and triptychs for private chapels, but the ivory art of England declined. In all probability the output from English workshops was much the same as before, but by the fourteenth century works produced bore no comparison in quality with those of the peak of twelfth-century achievement. As the fifteenth century advanced, with the late Gothic style remaining in favour in England, an increasing number of ivories of secular character appeared, but these too were inferior in workmanship and design to the elegant productions of French ivory carvers at about the same period.

Arab Craftsmen in Spain

In considering early European ivory work the richly ornate productions of the Hispano-Arabic workshops, which were in-

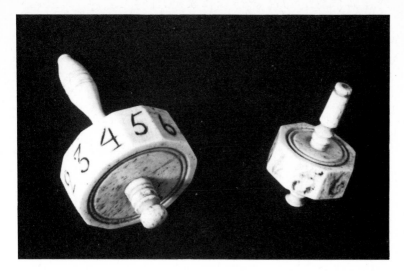

Teetotums – spinning toys. English (late eighteenth century).

tensely active in the tenth and eleventh centuries, cannot be disregarded. Spain under Islamic domination, when the Ommayad rulers at Cordoba encouraged artisans and craftsmen to leave Damascus and work at their court, boasted an ivory art that was unique in Europe. It is even possible that the art of carving in ivory in the Islamic world did not derive from eastern sources but evolved in Spain at the Ommayad court at Cordoba. A guild of ivory workers flourished at Cordoba as early as the eighth century, though surviving examples of Hispano-Arabic ivory work do not date farther back than the tenth century. Among the most interesting of the numerous surviving ivory caskets produced in Moorish Spain is the earliest one, made for a daughter of Abd--al-Rahman (912-961), the first western caliph.

A group of ivory workers were established in the palace of Medina az-Zahra, erected outside the gates of Cordoba in 966 by Abd-al-Rahman III. They produced many caskets, some of them carrying an inscription on the lower rim of the cover stating the date and for whom made; they were probably originally coloured, perhaps over a gold ground. Early examples were fitted with locks and hinges made of gold or gilded silver, for which coarse metal ones were later substituted. A fine ivory casket in the church at Fitero in Navarre is inscribed with the name of Halaf, an ivory worker, the date 966, and the name Medina az-Zahra. Halaf's name also appears after an inscription on a pyx in the collection of the Hispano Society of New York. Caskets were often ornamented with finely carved representations of birds and animals among foliage.

When the caliphate of Cordoba declined in the eleventh century and the ivory workers found themselves compelled to seek an outlet for their talents elsewhere, many sought employment in

39

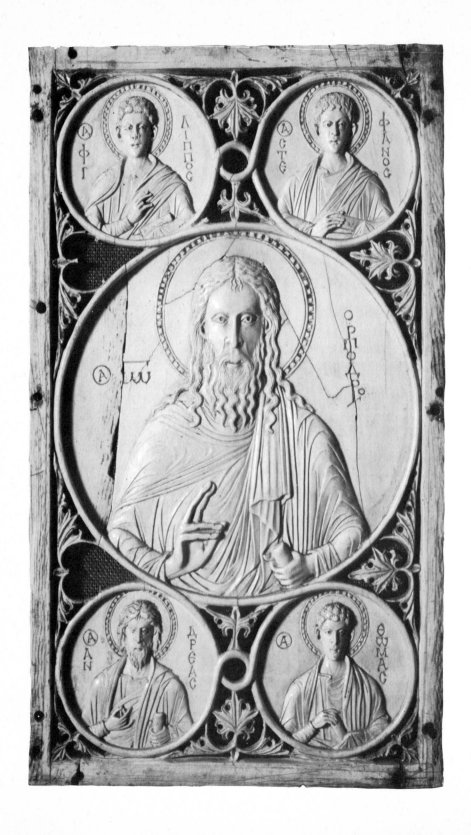

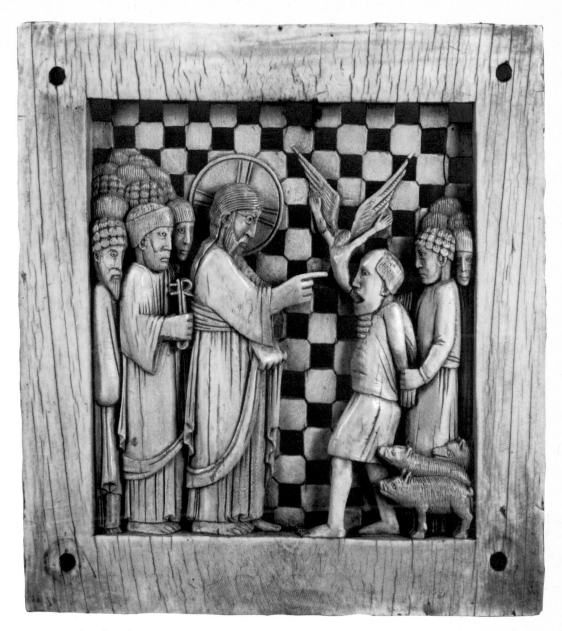

Left: Late 11th/early 12th cent. Byzantine relief in pierced ivory (probably from a book cover). St John the Baptist at centre; St Philip and St Stephen at top. St Andrew and St Thomas below

Exorcism in ivory relief: Jesus heals the man with the unclean spirit (Italian 10th century)

the ivory-carving centre at Cuenca in Castile, patronised by the Dhul-Munid dynasty who reigned as kings of Toledo. By the middle of the eleventh century, when Moorish power in Spain was waning, the ivory carvers of Toledo were already engaged in producing ivories for Christian patrons, and after the seizure of the Kingdom of Toledo by the Castilians in 1085 they turned to this entirely. Islamic art was superseded by Christian art with a distinctive Spanish character. Ivory carving did not die out, but rather the reverse, with workshops kept busy in the production of ivories for churches and private chapels and for secular use, as a new way of life began in Spain.

Early European Ivory Objects

When considering the ivory objects made in western Europe from early Christian times up to about 1600, rigid divisions of time and fashion are unsatisfactory, as styles generally overlap. Brief details are given of the general characteristics of the articles, examples of which may be studied in the more important museums.

Horns or 'oliphants'. (The name is a corruption of elephant.) These were made in variety in Europe and Asia through successive centuries. In England, and to a lesser extent in Scotland, the oliphant was mainly used for one of three purposes: as a drinking vessel, in the granting of land tenure or on appointment to office. Horns were also used to sound alarm or in hunting, but there is no documentary evidence to suggest that they were used as musical instruments. Ivory horns often contained holy relics and were hung up in churches. Oliphants of elephant ivory were rarer and more highly prized than those fashioned from the tusks of other animals, but the large size of an elephant's tusk normally precluded its use as a drinking vessel! In England, as already stated, an oliphant was presented when land tenure was granted or appointment to office took place, the tenure or appointment continuing while the 'tenure-horn' remained in the possession of the recipient or his heirs.

For a horn to serve as an instrument for sounding an alarm or summons, the tusk was hollowed out and the tip removed. For a drinking vessel, the tusk was hollowed out but retained its tip. Horns were often treasured as family heirlooms and handed down through successive generations. Carved English oliphants survive, also examples left plain and polished, but the most handsome horns are those fitted with silver mounts to which straps were attached enabling them to be hung from the shoulder.

Statuettes. Only a few of the surviving western European ivory statuettes can with any certainty be assigned to a date earlier than the beginning of the seventeenth century, although they were produced in monastic and other workshops from the thirteenth

century. The early examples can rarely be ascribed to a particular artist. Most of them are sensitively carved, with feeling for the material as well as the subject. A notable example, of particular interest because it retains its original colouring, is a fifteenth-century *pietá* in the British Museum that is assigned to South Germany. The theme of the Virgin and Child was a favourite with thirteenth and fourteenth-century sculptors: probably the best known ivory statuette of the early northern Italian schools, already referred to in this chapter, is the very moving Virgin and Child carved in 1299 by Giovanni Pisano, preserved in Pisa cathedral.

Diptychs. A diptych (from the Greek 'two-fold') consists of two tablets or leaves joined together by a hinge in the form of a book. Early Christian ivory diptychs were carved on the outside, with incidents from the Passion or the life of a saint, and the inner surfaces were either coated with wax to allow the name of a dead or living person to be inscribed when used at Communion, or they were left plain. In later times this arrangement was reversed, the leaves being left plain outside and the inner surfaces embellished with carving. The approximate age of diptychs can sometimes be determined by comparing carving with details of illuminated manuscripts executed in a similar style. Carving on early Christian diptychs is usually very detailed and executed with delicate precision. Diptychs continued to be produced through several centuries; many were subsequently adapted for use as book covers. It is rare to see a diptych or triptych with the original fastenings.

Triptychs. These triple-leaved carvings were often placed above altars, but few survive intact; the leaves of most have become separated. If a single leaf is examined it usually shows marks left by hinges.

Tau crosses An ivory tau cross often surmounted a bishop's pastoral staff. The cross took its name from the letter T('tau' in the Greek alphabet), which it resembled in form. Exceptionally fine examplescan be seen in the British Museum, the Victoria and Albert Museum and several Continental museums. English tau crosses are invariably fine, but one of the most beautifully carved examples known, long thought to be English, is now considered to be the work of a French ivory carver. It is in the Musée de Cluny, and is astonishing in the richness of its ornamentation. Tau crosses were most commonly mounted on the heads of pastoral staves, during the eleventh and twelfth centuries. Walrus ivory was frequently used.

Croziers. Curved ornamental heads on bishops' pastoral staves appeared later than the first tau crosses. Carved ivory staff-heads of this type are for the most part brilliantly executed miniature works of art, the amazingly complex design incorporating

figures, groups and religious emblems intertwined with foliage.
Combs. Liturgical combs may surprise the student of ivories unaware of ancient religious usage. The combs were of the same shape as combs in secular use in early periods, with two rows of teeth held by a central bar, usually lavishly carved. It was important for clergy officiating before the altar to be ceremonially clean and the custom of combing the hair before divine service was strictly observed. In England this lapsed with the Reformation. Several sixteenth-century liturgical combs have survived, but specimens that can be safely ascribed to an earlier period are rare.

Pyxes. Usually circular in shape, made to contain the Sacred Host or the consecrated bread for the Sacrament. Pyxes were made from elephant and walrus ivory, the latter more often used by early Christian carvers, and fitted with hinges and occasionally locks. Most pyxes were fashioned from hollowed-out pieces of tusk carved with Biblical scenes.

Caskets. Made from ivory in every conceivable size and shape, their design perpetuated the style of boxes made in ancient Egypt, Rome and Byzantium. Made for all purposes, they were almost invariably of high artistic standard, those intended to contain jewels being regarded as worthy of the craftsmen's utmost skill. Splendidly carved ivory caskets were used in churches to contain relics of saints: these reliquaries included caskets made of precious woods decorated with finely carved ivory plaques. Carving usually depicted religious subjects, sometimes including scenes from the life of the saint whose relics lay within.

Mirrors. Before the late sixteenth century, mirrors were seldom made of glass. An alloy of copper and tin known as speculum was generally used for small highly polished metal mirrors, circular and often enclosed in carved ivory cases. Mirror cases dating from the fourteenth century are extremely beautiful. Some are double, with the mirror fitted inside. The backs were usually carved with romantic scenes of feminine appeal. A French example of this period, considered by many authorities to be the most beautiful mirror case in existence, is in the Mayer Collection at Liverpool. Its masterly carving depicts a lady surrendering to a knight who lifts her out of the window of the Castle of Love and bears her away. The lovers are also depicted seated in a boat accompanied by a musician and oarsman. Three mirror cases carved with an identical scene are in the Victoria and Albert Museum: lovers are seated in a tent finishing a game of chess; apparently the knight has won the game and the lady is recoiling from her defeat. These too are French, dating from the first half of the fourteenth century.

Gaming Pieces. Chess was being played in Italy in the eleventh century, by which time the game had reached Europe from the

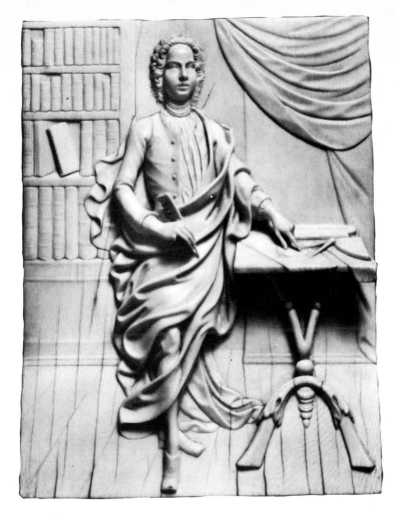

Near East. Among the earliest examples of chesspieces known, and probably the most important discovery of its kind yet made in the British Isles, was the hoard of nearly a hundred carved ivory chessmen found in a sandbank by a workman on the island of Lewis in the Hebrides in 1831. Whether the chessmen are of Icelandic or Scottish origin has been disputed, but as the early style of carving in Scotland and Scandinavia was similar the argument is unlikely to be decided. Parts of seven chess sets, some sixty-seven pieces in all, are now in the British Museum and the remaining eleven pieces are in the National Museum of Scotland, Edinburgh. The chessmen, carved from walrus (morse) ivory, can be assigned with certainty to the twelfth century, the figures appearing in the costume of the period. Some of them are seated upon chairs or thrones, the backs embellished with interlaced

45

scrolling. Walrus ivory was used for early European chessmen, that is to say chessmen from western Europe and Scandinavia dating principally from the eleventh, twelfth and thirteenth centuries. Ivory chessmen and chess-boards were used extensively in England during the Middle Ages, as is evident from their frequent mention in inventories and wills of the period; as the art of ivory carving was practised in England from at least as early as the tenth century, chess sets must have been carved in medieval times. It is a point of curiosity as to why ivory chess sets were not more highly prized and in consequence preserved through the centuries.

A notable chesspiece preserved in the Salisbury & South Wiltshire Museum is a rare twelfth-century king carved from walrus ivory. It resembles the Lewis chessmen in style.

Many examples of ivory draughtsmen carved in the eleventh, twelfth and thirteenth centuries still exist, generally in walrus ivory. Draughts is not as ancient a game as chess and may have originated in France in the late eleventh or early twelfth centuries, spreading across western Europe a century or two later. Walrus ivory draughtsmen scattered among public and private collections throughout the world mostly date from the eleventh, twelfth and thirteenth centuries. Circular gaming discs made of ivory, which may not have been used in the game of draughts as we know it today, have survived in considerable number. These are often ornamented with carved figures of people and animals, the most interesting depicting players engaged in contest watched by spectators.

Articles of religious usage were undoubtedly considered as of prime importance by ivory workers from the dawn of Christianity to the Renaissance. But in changing times, many objects intended for religious ceremonial were acquired for personal or domestic use – or even vice-versa, the Church acquiring secular ivories. Ivories seized during the despoliation of monasteries and other religious establishments might subsequently be displayed as ornaments in private houses. Whether richly coloured and gilded, or left to mellow in its natural beauty, ivory held great allure throughout the Middle Ages in Europe. Fine jewellery was, to many who had money and appreciated beauty and craftsmanship, no more to be coveted than superb ivories.

Rare and Costly Treasures

Only affluent collectors can attempt to seek out, and hope to be able to afford, even mediocre examples of early European ivories. Whatever one's resources, ivories of pre-Renaissance date are nearly all in public and notable private collections; even from the latter, there is little chance of any appearing in salerooms. There may conceivably be rare treasures as yet unrecognised in

places where an 'ornament' has been shut in a cabinet and passed from one generation to another until it virtually ceases to be noticed, but the quality and interest of an ancient ivory is unlikely to have escaped attention.

The collector with ample funds and interested in early European ivories is best advised to watch for occasional important sales of privately owned ivories. Reports and catalogues of forthcoming sales can be obtained from the world's top auction salerooms, where he should make his wants known. If he knows one or more reputable specialist dealers, he can request them to keep an ear to the ground for news of suitable items owners may be considering selling. Private negotiation may possibly be arranged.

For the rest, no doubt the beauty of rare early European ivories can only be admired in museums; but as already stressed, no prospective collector of ivories of whatever type or period should neglect inspecting ivories of quality. Looking at the best is the only sure way to improve taste, learn to recognise excellence and avoid being deceived by forgeries. Knowledge of style and techniques is invaluable.

5 Later European Ivories

With Italian artists at first taking the lead, ivory carving in western Europe underwent important changes during the sixteenth century, both in style and the techniques employed. As the Renaissance brought a decline in the production of religious ivories, Italian ivory carving sank to a low ebb for a considerable period. Elsewhere, particularly in Germany and Austria, where the baroque style rapidly gained ascendancy, and in the rococo period which followed, the art of ivory carving flourished as never before. New techniques developed in Germany were quickly adopted in the Low Countries and then in Britain.

Germany Takes the Lead

Baroque taste inspired production of ivory statuettes and groups, the latter sometimes carved from a piece of tusk cut lengthways. As many artists took the trouble to make a serious study of

Extreme left: Plaque with carving depicting Hindu gods, with five other individual carvings mounted on sections of an elephant's molar tooth (late seventeenth or early eighteenth century).

anatomy, statuettes carved in the round gained in symmetry. Numerous groups of ivory carvers developed individual styles which, though largely reflecting the German and Austrian interpretation of baroque, in some instances showed remarkable originality. The use of the lathe, a sixteenth-century innovation, facilitated working to extremely complicated designs. A new realism was achieved with the execution of greater detail in relief.

Possibly the most universally popular items in ivory produced by carvers in eastern Europe during the seventeenth century were crucifixes. Whether magnificently or indifferently carved, they were made in large numbers in practically all countries, especially the Catholic ones. An ivory figure of Christ was usually mounted on wood, although some small crucifixes were carved completely from ivory. A few artists experimented. Simon Troger, the German ivory carver, excelled in a technique which entailed using ivory to represent flesh and wood for the clothing. This type of production became popular in Germany, though the ivory carvers failed to produce work comparable with Troger's masterpieces.

Among the most remarkable objects usually assigned to German ivory carvers are the massive silver-mounted tankards now admired by many collectors. Beer mugs, goblets and tankards were produced in quantity, though some of the large, superbly decorated ones which must have been intended for display rather than use, were probably produced in Flanders, only their silver ornamentation being added in Germany. Tankards were made as much as a foot in height and six inches in diameter, richly carved with mythological and Bacchanalian scenes. Some of those exquisitely decorated with scenes inspired by Rubens are clearly not of German origin. Whether or not Faidherbe, a pupil of Rubens, did in fact carve any of the ivory tankards now assigned to him by some experts is still open to debate, but there is strong reason for believing them to be Flemish.

Far more ivory carving was produced by Germans, professional and amateur, during the seventeenth and eighteenth centuries than anywhere else in Europe at the same period. Princes learned to carve in ivory, professional ivory sculptors earned a handsome living from portraiture, and as amateurs without number discovered the malleability of ivory and how easily it could be worked, vast quantities of the material were imported regularly from West Africa. Entire families engaged in ivory carving in their own workshops, as for example the brilliant Zick family at Nuremberg.

Portrait busts, medallions and statuettes became popular. The most skilled professional artists produced fine portraits in low relief on circular medallions resembling coins. Some of these,

whether depicting important personages of the time or unknown individuals, are truly works of art and are deservedly given a prominent place in collections. Figurines of all kinds were produced, but as time went on the increasing popularity of porcelain caused ivory carvers to desist from sculpture. Among the most beautiful objects of other kinds carved from ivory were decorative plaques and game dishes. These were generally executed without characteristic German heaviness and were free from excessive ornamentation. Designs were usually complex and striking. The items were rivalled in quality by the so-called 'diptych' folding dials used before watches appeared: the dials were exquisitely engraved, the numbers appearing among cherubs and fine interlaced scrollwork. The names of makers are usually found inscribed on such pieces, the best of which, so far as Germany is concerned, were made in Nuremberg; of particular interest are examples carrying views of that city. Similar ivory 'diptych' dials were produced at Dieppe in France at the same period. These, too, are usually found to be of the highest workmanship. Such items as tobacco graters, powder and hunting flasks, handles, game dishes and snuff boxes were enriched with fine carving, sometimes executed with amazingly minute detail.

It was a period of scientific enquiry. German ivory carvers found employment producing scientific instruments such as pocket calculators, drawing instruments and microscope parts, and the superiority of ivory for surgical instruments was discovered.

For the wealthy, large cabinets were made to contain ivories and other treasured possessions. The cabinets were embellished with beautifully carved plaques often depicting scenes from classical mythology.

German goldsmiths who became attracted to ivory carving specialised in the production of ivory figurines in a favourite genre inspired by Quast's engravings after Van Ostade. The figures were usually embellished with touches of enamel and silver-gilt, among the best being charming figures of tradesmen. Statuettes of beggars and peasants delighted the rich upper-class families who acquired them for cabinet display.

Such German ivory carvers as S. Zick and Heinrich produced curiosities, including weird anatomical carvings such as representations of various organs and skulls, Siamese twins, and other oddities. Other carvers emulated the Chinese by producing elaborately carved balls, one inside the other, cut from a single piece of ivory.

A school of ivory carvers founded at Ulm in Germany by David Heschler in the late seventeenth century subsequently became a noted centre under the direction of Johann Michael Maucher.

France: from delicacy to lavish ornament

The port of Dieppe became pre-eminent in France as an ivory-carving centre, developing a tradition of fine craftsmanship handed down from one generation to the next from the beginning of the eleventh century. From the end of the fourteenth century West African ivory was imported in huge quantities, and the reputation of the town as an ivory-carving centre grew through the centuries, reaching its apogee in the seventeenth century when travellers passing through the port were frequently captivated by the beauty of the ivories offered for sale. Dieppe ivories displayed a delicacy and lightness of touch absent from German work; even the most diminutive objects were fashioned with a characteristic sensitivity. It became a custom with Dieppe ivory workers to mark their creations with their individual symbol, which helps modern collectors in attribution. Production has continued to the present day.

The only serious rival to Dieppe was Paris, where the workshops kept busily turning out small religious and secular objects that on the whole lacked the charm of Dieppe productions. Paris ivory carvers were stimulated into greater activity after 1694 when the British and Dutch naval bombardment of Dieppe shattered the town, destroying the ivory ateliers and thus eliminating their only serious competitors in France; intensive production in Paris followed, but quantity did not compensate for inferior quality. After the naval bombardment of 1694, ivory work in Dieppe itself was halted for a long period, but

Outside: Pair of carved elephants from Ceylon. *Inside:* Two candlesticks. Japanese (nineteenth century).

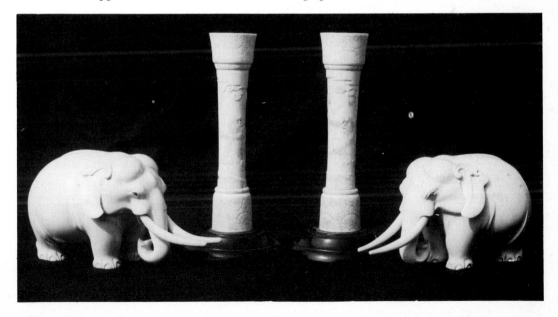

workshops near the port that escaped damage continued active and by the middle of the eighteenth century ivories were once more being produced at an increasing rate, although Dieppe never recovered its former prosperity and prestige as a leading centre. In the following century ivories were produced in Dieppe in large quantity, but they were much inferior to the beautiful objects of earlier times..

In the late seventeenth century workshops in both Dieppe and Paris produced boxes of all kinds, scent bottles, fan handles and bibelots which were not particularly original. The most exciting work of the period was a series of carved ivory portraits produced by several notable artists, including Le Marchand and Cavalier. Relief work was of extraordinary quality, especially Cavalier's. A series of exquisite snuff boxes surmounted by carved portraits of notable personages – Voltaire and Rousseau were popular subjects – issued from the flourishing atelier at Sainte-Claude conducted by a talented family of ivory carvers named Rosset.

In France the fan became an article upon which ivory carvers particularly lavished their skill. It first appeared in France about 1422, and its design passed through several phases of development. Ivory carried rich materials which did not invariably cover the ribs of the fan but sometimes left them partly exposed in order to display beautiful pierced work. Fan handles made of ivory were lavishly ornamented with carving that changed in style through successive reigns or periods, being especially exuberant, of course, in the baroque and rococo periods.

Italian Decline

The decline of the ivory-carving centres in Italy from the beginning of the Renaissance may have been due to difficulties in obtaining supplies of Indian ivory after the trade routes to the east were cut. Important urban centres were most affected, while in provincial areas ivory workers who had formerly specialised in *objets d'art* turned to utilitarian articles which they did not consider worthy of fine workmanship and decoration. Moreover, techniques better suited to monumental sculpture began to be employed, promoting a general tendency towards heaviness in design and workmanship. Although imitations of large sculpture were not altogether successful, groups of ivory carvers working in different localities in northern Italy did produce charming small sculptures displaying something of the beauty and grace characteristic of Pre-Renaissance Italian ivory sculpture. At this time, during the late sixteenth century, Italian ivory workers commenced production of splendid furniture embellished with intarsia of ivory and mother-of-pearl.

Many subsequently celebrated ivory carvers received their

training in Italian schools, including Permoser, Von Lücke and Elhafen. In Germany it was considered essential that young aspiring sculptors, whether intending to work in wood, stone or ivory, should spend at least a few years in one of the great Italian art centres before returning to their native country. The Italian masters, it was considered, stood above the decline in artistic standards. Some notable Italian ivory carvers did remain unaffected by the general debasement of style, including artists of the calibre of Antonio Leoni and Algardi belonging to the same school. Late in the seventeenth century an Italian named Bocenigo or Bonzanigo, working in Asti, failed to achieve the recognition he deserved as a master carver in ivory: his carved figures and portrait medallions were of considerable beauty, his carving of foliage distinctive. A portrait medallion of the Empress Marie-Louise now displayed in the Louvre leaves no doubt of Bocenigo's talent, although outside museums at Asti and Turin his name is practically unknown.

Patronage in Britain

While ivory carvers were extremely active on the Continent during the seventeenth century, especially in the ateliers of Flanders, Germany, France and Italy, conditions were rather less favourable to production in Britain, where civil strife suspended activity among artists and craftsmen; many deprived of the chance to earn a living during the years of the Civil War and Commonwealth found employment in Continental workshops. In the eighteenth century, however, increasing prosperity and more settled times brought a great revival of interest in the fine arts among the upper classes. Foreign ivory carvers set up workshops in London and elsewhere, becoming fashionable and making their fortunes at portraiture in ivory. The most notable of these was David Le Marchand, who enjoyed high repute in his native France as well as in England where he spent his most productive years carving ivory portraits of royalty, aristocracy and others who could afford the luxury of commissioning a portrait medallion or bust of themselves from him.

The work of German and French ivory carvers was also imported to Britain on a considerable scale. A number of workshops in Rhineland cities, in the vicinity of Dieppe and in Paris established regular connections with merchants interested in the distribution of Continental ivories in England.

The English upper classes took to travelling on the Continent in ever-increasing numbers in the eighteenth century, and many of them passed through Dieppe or visited Flemish and German cities where ivories were being produced on what amounted to a commercial scale. In this way the travellers became aware of ivories and many took attractive pieces home with them, and

ivory souvenirs of Continental travels became fashionable. Some ivories took their place as household ornaments, while others such as ivory jewellery and toilet and dressing-table articles were worn or used by society ladies. Ivories were almost as much a part of interiors and the social setting as porcelain, silver and jewellery. Those who could not afford genuine ivories had to be satisfied with bone imitations.

Strong Realism in Spain

Spanish schools became important in the later Renaissance: Alonso Berruguete's atelier was especially celebrated. Most ivories produced in Spain and in Portugal were intended for devotional use, and many of them are inferior, somewhat coarse and commonplace. For the most part, Spanish ivories were strongly realistic and were frequently painted. Ivory was also on occasion treated like stone in sculpture, as is seen in the striking work of the eminent sculptor Pedro de Mena. Alonso Canos was another seventeenth-century artist of exceptional talent, as is evident from his wonderful ivory figure of St Sebastian. The school of Valencia, in its best period during the early eighteenth century, became noted for fine work. Tiny reliefs in ivory by Ramon Capuz attracted wide attention during his period of activity in the late seventeenth century. Capuz, born in Valencia in 1665, also became noted as the creator of charming ivory polychrome figures of beggars. Another Capuz, a Dominican friar and a brother of Ramon, achieved some repute as an ivory carver, though not ·in the same class.

Portuguese carvers worked with Indian ivory brought from Goa after Portugal established her eastern colonies in the sixteenth century, though the rather coarse, over-elaborate ivories of the period are sometimes thought to be the productions of native carvers in Goa made for export to Portugal. Representations of the Good Shepherd, Madonnas and crucifixes were produced in quantity in both Goa and Portugal.

Master Carvers

In the highly select list of master carvers active in Europe in the seventeenth and eighteenth centuries that follows, artists are listed under country of birth.

AUSTRIA

Auer, Jakob A sculptor working in Vienna 1697-1704. Carved ivory groups in relief.

Deutschmann, Josef (1717-82) A native of Imst in the Tyrol. Some of his ivory carvings, of good standard, may be seen in churches around Passau, Germany, where he died.

Faistenberger, Andreas (1647-1736) Possibly born at Kitz-

bühel, a member of a family of artists. Specialist carver in ivory, stone and wood. Worked chiefly in churches around Munich.

Rauchmiller, Matthias (1645-86) Sculptor, architect, engraver and painter. Noted ivory carver.

Troger, Simon(c 1693-1769) Born at Abfaltersbach; died at Haidhausen, near Munich. Specialised in working with wood and ivory used in combination to create figures on a larger scale than otherwise possible. Studied the art of sculpture at Innsbruck under Nikolaus Moll and worked at Munich with Andreas Faistenberger.

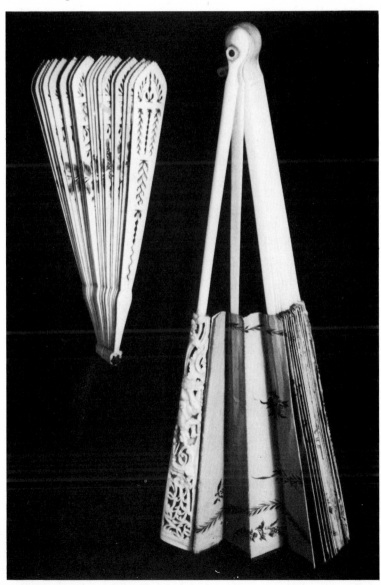

Chinese fans (nineteenth century).

ENGLAND

Bevan, Silvanus (1691-1765) A Quaker apothecary who developed an amateur talent for portraiture in ivory. Nearly all the numerous ivory portraits known to have been carved by Bevan have disappeared. His celebrated portrait of William Penn, the founder of Pennsylvania, served as a model for Josiah Wedgwood in the production of a jasperware plaque.

Cheverton, Benjamin (c 1794-1876) Inventor of a machine for producing copies of sculpture, same size or reduced, he made miniature reproductions in ivory of famous statues. Whether these were machine or hand finished is uncertain. He signed much of his work.

Lucas, Richard Cockle (1800-83) A native of Salisbury, Wilts. A gifted modeller and carver, able to work in a variety of materials. His two scale models of the Parthenon, showing the temple before and after it was blown up by the Turks in 1687, may be seen in the British Museum. His ivories comprised a variety of types. Collectors will find it worthwhile to study the collection of Lucas ivories presented by him and now displayed in the Bethnal Green Museum, London.

FRANCE

Cavalier (or Cavailer), Jean Presumably a Frenchman, but not known to have worked in France. An ivory worker of considerable skill, active in England, Germany, Denmark and Sweden during the later seventeenth century. Dates of birth and death are not recorded. Displayed exceptional skill in the execution of medallions.

Marchand, David Le (1674-1726) A native of Dieppe. Le Marchand became celebrated for his fine ivory carving in England where most of his working life was spent. Noted for busts and plaques. Signed most of his works.

Rosset family A celebrated trio of ivory carvers who worked at Sainte-Claude in south-eastern France. Joseph, the father (c1703-86), was assisted by his two sons Jacques (1741-1826) and Antoine (1749-1818). Although all carved religious works, particularly statuettes and crucifixes, Joseph Rosset's crucifixes were outstanding. The three men are credited with a series of carved ivory busts of famous men.

GERMANY

Angermair, Christof, Date of birth unknown; died c1633. Born at Walheim. Became court turner to Maximilian I of Bavaria and worked at Munich 1618-31. Produced excellent ivories with microscopic detail. A richly ornate coin cabinet covered with carved ivory plaques and surmounted with an equestrian figure of the Emperor Maximilian made in collaboration with Peter Candid is accounted Angermair's finest work; it

is displayed in the Bayerisches National Museum at Munich.

Baur, Johann (1681-1760) Probably passed all his working life at Augsburg, but may have been born and brought up at Worms. Carved in wood and mother-of-pearl as well as ivory. His ivory groups show close attention to detail and the figures are free from the heaviness which so often mars German ivory sculpture of the period.

Elhafen, Ignaz (1656-1716) Thought to have been born in Bavaria and known to have studied ivory carving in Rome. Arrived in Vienna in 1685. Summoned to Düsseldorf by the Elector, he later married the prince's sister. Elhafen specialised in ivory statuettes, carved with a master touch that raises them above the commonplace. Despite a tendency towards over-elaboration, his nymphs and satyrs were modelled with a high degree of artistry. He gave his figures animation and vitality to an extent not often achieved in German ivory sculpture of the period.

Harrich, Christof An ivory carver of some note active in Nuremberg during the second half of the sixteenth century, but little is recorded. He specialised in the creation of the once fashionable morbid curiosities in ivory such as skulls, *memento mori* as they are known: reminders of the certainty of death.

Kern, Leonhard (1588-1662) A native of Forchtenberg. Studied in Italy and subsequently settled at Hall, near Stuttgart, in 1620. Little survives of his work, which was usually signed in monogram. Executed sculpture in marble.

Lenckhardi, Adam (1610-61) Born at Würzburg, died at Vienna. Carved ivory objects for the Lichtenstein Museum of Curiosities, including eleven statuettes. A number of important museums contain examples of Lenckhardi's work.

Lücke, Johann Christof Wolfgang von A native of Schwerin; died 1780. Member of a noted family of sculptors that included ivory carvers. Trained as a sculptor, but also became a talented carver in ivory and well known as a modeller in porcelain. In 1732 succeeded Permoser at the court of Weimar. The Lückes of Kassel became noted for ivory portrait medallions. A tradition of fine ivory carving endured in the family, passing from father to son.

Maucher, Christof and Johann Michael Probably related: both born at Schwäbisch-Gmünd, the former c 1642 and the latter 1645. Christof probably died at Danzig, Johann died at Würzburg. The Mauchers carved ivories in the flamboyant mode of the period and their works have been criticised for extravagant elaboration. Nevertheless, the ewer attributed to Johann Michael Maucher in the Victoria & Albert Museum, richly carved with figures in high relief and with its handle in the form of a winged caryatid, is a rather interesting example of German late

Left: Miniature back scratcher (late eighteenth century). *Right:* Hand of a back scratcher (nineteenth century). Both Chinese.

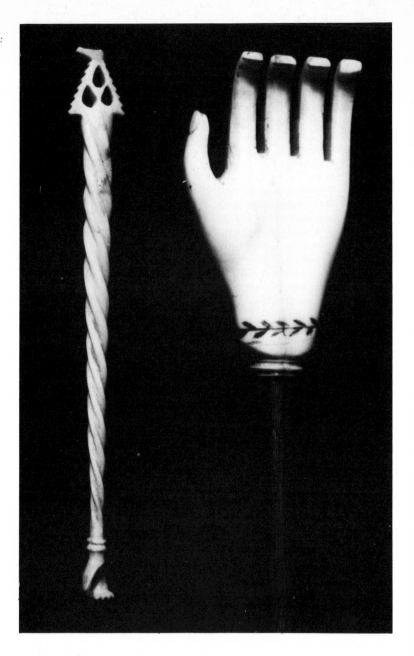

seventeenth-century ivory carving.

Permoser, Balthasar (1651-1732) Studied in Italy and worked there for fourteen years. A versatile sculptor, primarily in wood and stone, but his ivory carving was exceptionally skilful. Permoser's fine sculpture executed at Dresden, where he died, earned him enduring fame. His *Winter* and *Spring* ivory statuettes in the Germanisches Museum at Nuremberg attest to his skill.

Petel, Georg (c 1590-1634) Born at Walheim. Executed his best works in ivory at Augsburg, where he spent most of his short life. Petel's wood carving was in no way inferior to the excellent ivories attributed to him.

Stockamer, Balthasar An ivory carver active in Nuremberg in the late seventeenth century. It is recorded that Stockamer enjoyed the patronage of the Medici family, but otherwise little is known about his life and work. A finely carved, impressive crucifixion scene exhibited in the Pitti Palace, Florence, demonstrates why the Medici favoured him.

Zick family The celebrated Zick family of artists at Nuremberg included ivory carvers; the most notable was Peter Zick who taught ivory carving to Rudolph II, Emperor of Austria.

ITALY

Bocenigo (or Bonzanigo) Giuseppe Maria (1744-1820) A native of Asti who worked in Turin for most of his life. He carved excellent portrait medallions in ivory and also worked in wood, also almost invariably on a small scale. His ivory tobacco jars were carved in minute relief. Bocenigo's carvings of foliage were of exceptional quality. Notwithstanding the quality of his work, it is little known and has attracted slight attention outside Italy.

LOW COUNTRIES

Bossuit (or Bossiot), François, (1635-92) A native of Brussels; died in Amsterdam where he had earned high repute as an ivory carver. Studied and worked in Italy and Holland. Few examples of his work in ivory have survived, but his skill is beyond doubt. Thirty-five years after his death a book of engravings of his works was published in Amsterdam and the illustrations show clearly the high standard and originality of his ivories. The book, issued in 1727, refers to the artist as 'the famous Francis van Bossiot'.

Duquesnoy, François (1593-1643) Born in Brussels; died at Leghorn. One of the most celebrated and prolific artists of his time in various media; known as 'Il Fiammingo' – the Fleming. His most important works were executed in Rome, where he established himself in 1618. Besides fine ivories, he created superb bronzes and also modelled in terracotta and wax. Reliefs and statuettes in ivory and other materials were produced in astonishing quantity in his renowned Roman studio. Much is known concerning Duquesnoy's life and work as a sculptor in marble, but there is very little reliable information about his productions in ivory. Il Fiammingo gained wide repute as a modeller of children in groups and figures; his models of boys were considered incomparable. His works were unsigned. Duquesnoy became an artist of international repute.

Faidherbe (or Faydherbe), Lucas (1617-97) Born and died at Malines, Belgium. A pupil of Rubens who exerted strong influence upon his style, to the extent that Flemish ivory carvings featuring women and children after Rubens are assigned to Faidherbe almost without question. As Faidherbe apparently did not sign his ivories – no signed work by him is known to exist – examples in various collections may not all be his work.

Galle, Ambrose Died at Antwerp 1755. An ivory carver active there during the first half of the eighteenth century.

A number of signed ivories by Galle are extant and it is possible that other, as yet unrecognised, ivories by him will eventually be discovered.

Hagen, Gaspar van der (or Vanderhagen) The dates and places of the birth and death of this accomplished carver are not known. He worked in England in both ivory and marble. According to George Vertue, the antiquary, Van der Hagen was employed for a period by Rysbrack. An ivory bust of the Duke of Cumberland executed in 1767, inspired by Rysbrack's original in marble, now in the Victoria & Albert Museum, attests to the quality of Van der Hagen's work. Vertue referred to the artist's 'head portraits in ivory'. Apparently Van der Hagen was not encouraged in the production of ivory busts. He was granted a pension from the Royal Academy and as payment terminated in 1775 it is assumed to be the year of his death.

Opstal, Gerard van (c1597-1668) A native of Antwerp, strongly influenced by the work of Rubens. Within a few years of his arrival in Paris in 1643 he became chief sculptor to Louis XIII. Van Opstal's reliefs in marble executed for the decoration of French palaces won high praise. Ivory reliefs depicting plump children at play, in Rubens' style, are assigned to him.

Verskovis, Jakob Frans A Flemish ivory carver who first worked in Rome. According to George Vertue, he was persuaded by English visitors to Rome to settle in England, where they predicted there would be a great demand for his work. His hopes were not realised and he fell on hard times. In 1743 Horace Walpole wrote to his friend Sir Horace Mann informing him that he had received delivery of a cabinet with 'the doors inlaid with carvings in ivory'. The cabinet, now in the Victoria & Albert Museum, is embellished with eighteen Italian ivory plaques carved in relief by Verskovis. Upon the pediment are three bearded male ivory figures, also by Verskovis, stated by Walpole to represent the architects Andrea Palladio and Inigo Jones and the sculptor Il Fiammingo: it is now accepted that Walpole was in error, since Palladio never wore a beard, and that the Palladio figure should correctly be identified as Rubens. Thus the three figures represent Painting, Architecture and Sculpture. The figures, also the attractive Italian ivory plaques, offer rewarding

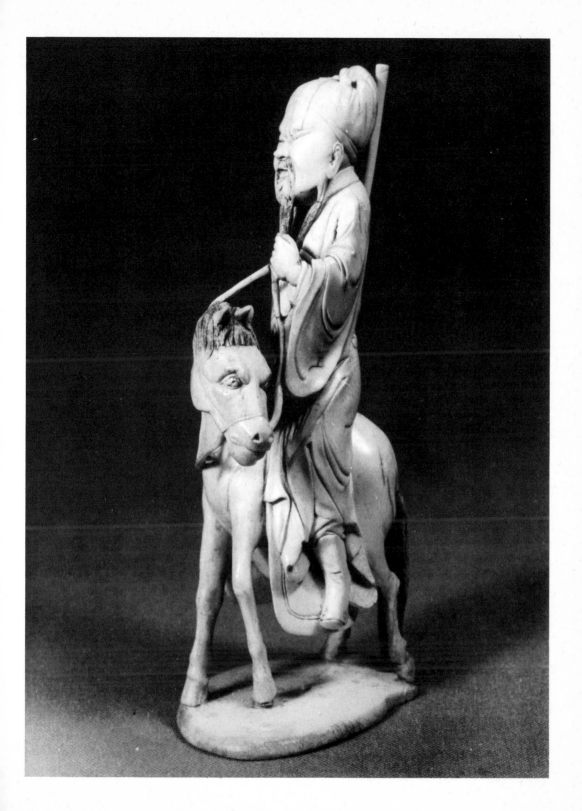

study to students of ivories.

Chess Sets

Chess sets are among the most beautiful and interesting items made by ivory workers in western Europe from the late Renaissance period onwards, although very few of the earlier of these have survived. By the seventeenth century chess sets were being produced in large number in several European countries, especially in Italy, France and Germany, and some magnificent examples appeared. Manufacture of chess sets in England on an appreciable scale did not begin until the early nineteenth century.

In some regions, Flanders for example, where craftsmanship in ivory attained a high level, chess sets were only regarded as a sideline, which is surprising when the beauty of Flemish chesspieces is taken into account. In France and Germany, however, the carving of chesspieces developed into a full-time occupation for many ivory workers. From the beginning of the eighteenth century the game rapidly gained popularity round Europe. As wealthy noblemen became increasingly addicted to it, some truly beautiful, superbly decorated sets were commissioned from the best carvers. Various materials were used, but principally exotic woods and ivory, with the latter by far the most popular, albeit the most costly.

It is known that ivory carvers working in the flourishing ateliers of Florence and Milan made fine chess sets in the sixteenth and seventeenth centuries. These, in the nature of works of art, were specially made for a rich patron. With the passage of centuries early Italian chesspieces have disappeared. Optimistically one may envisage a fortunate collector lighting upon a solitary begrimed but magnificent piece from an early set in a dark corner of a junk or curio shop in a remote Italian provincial town — perhaps.

During the late eighteenth century Italian ivory carvers were producing substantial quantities of decorative chess sets. A surviving example, made in Florence in the third quarter of the eighteenth century, has identical pieces for each contestant except that one set is stained light green. Kings and queens appear as Roman emperors and empresses. Italian and German chess sets of the type are much alike in appearance and the carving techniques were practically the same, the German version usually being larger and heavier. Italian chesspieces of the later eighteenth century were executed in a variety of brilliant designs, perhaps the most outstanding being the piscatorial and zoomorphic pieces: people, birds, insects and fish were often depicted in humorous vein.

Skilfully carved and turned ivory chesspieces of superior quality were also made in French workshops during the

eighteenth century. While Paris and Dieppe were the principal French ivory-carving centres, numerous small workshops existed throughout the French provinces. The best French carvers worked with remarkable precision and skill, creating well-balanced and carefully finished articles; their chesspieces, even when of simple design and intended for playing, usually showed imagination, originality and humour, sometimes portraying well-known personalities of the time, especially political figures. When the struggle between Napoleonic France and England began, for instance, the features of opposing political and military leaders soon appeared on chesspieces. Chess was in fact a popular game in France throughout the eighteenth century. Before the Revolution travellers making lengthy coach journeys frequently kept themselves amused with it, using pieces with spiked bases held in position on a cushion chessboard.

Eighteenth-century German craftsmen produced ivory chess sets of beauty and workmanship unsurpassed in any other western European country at the time. It is only necessary to examine a piece from one of these sets, noting the mastery of technique, the beauty and elegance of design, and the careful attention given to detail in carving, to appreciate the German ivory carvers' supremacy. African ivory was invariably used in quality productions. Workshops in various parts of Germany made excellent playing sets, but the two principal centres of production during the eighteenth century were Nuremberg and Augsburg, where the most talented artists were employed.

In many German portrait chess pieces, the eyes were pierced and coloured, achieving a very realistic effect. The well-known 'Reynard the Fox' chesspieces were more plentifully made in Germany during the nineteenth century but did in fact originate in the second half of the eighteenth century; the pawns were often carved to represent monkeys.

Chess sets were also produced on a fairly extensive scale in the Low Countries during the eighteenth century, principally in Holland. Sets intended for playing were often made in wood or bone, the ivory ones being costlier and more for ornament than for use. The best Dutch chesspieces are not inferior to the finest German and French examples of the same period. The ivory carvers here kept to a series of basic patterns, with variations according to the whim of the craftsman. Earlier Dutch chesspieces, it will be observed, are often on the small side compared with, for example, German pieces.

The standard of ivory work in Spain during the eighteenth century was generally high, though perhaps not on the artistic level of carving produced in some other western European countries, such as Flanders. Spanish ivory carvers do not appear to have turned to producing fine chess sets; ivory chesspieces of out-

standing quality are rare. However, collectors interested in old ivory chesspieces will undoubtedly learn of the well-known 'traditional Spanish' or 'pulpit' pieces, as they are called. These were mostly produced by a school of carvers active in Spain during the second half of the eighteenth century, and bear no resemblance to any other chesspieces produced in western European workshops. Each piece has a curious turned and carved gallery in the form of acanthus leaves and is mounted on what can only be referred to as a pulpit. Although the majority of such sets were carved in bone, a cheaper but much more difficult medium to work with than ivory, some excellent ivory sets were produced. One version, generally found carved from ivory, has the principal pieces enclosed, or perhaps mounted would be more explicit, inside pulpits shaped as acanthus leaves.

Lastly there are the well-carved, and in some respects novel, ivory chesspieces made in Russia after the beginning of the eighteenth century. The most striking are imitations of pieces used in the ancient original Indian version of chess, the game *chaturanga*. Russian carvers worked with the same expertise in mammoth or walrus ivory. Their sets were nearly always made with both contestants' pieces identical, one side being coloured red or brown.

A Wise choice for Novices

A collector of only modest means stands a reasonably good chance of finding examples dating from the period covered by this chapter, particularly items of western European provenance made during the second half of the eighteenth century. Ivories were always produced in greater volume on the Continent than in England, and Continental ivories are more easily found than English examples. French and German workshops were the most productive ivory-carving centres in Europe during the eighteenth century. It may well prove more rewarding for a novice collector of limited means to confine his searches for ivories of the late eighteenth century to these two countries.

Less knowledgeable dealers can inadvertently cause confusion and dismay to a beginner by mistaking the date and source of an item sold. The occasional lapses of dealers, who cannot be infallible, can, as already pointed out, sometimes prove advantageous to a collector who has taken the trouble to learn all he can and also gained a practical notion of values. Naturally anyone who decides to collect only English ivories will wish to avoid unwittingly acquiring, say, a French piece. Discovery of error in attribution or description are hardly likely from a specialist dealer known to be an expert in his particular field, but a dealer handling many different types of items may correctly judge an ivory to be genuinely old but be mistaken about its source. If the collector

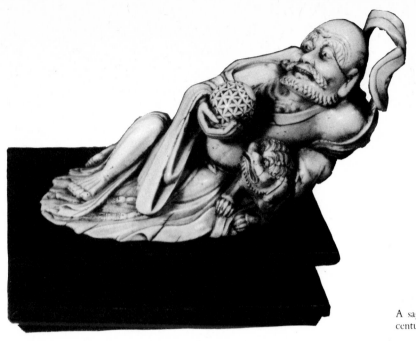

A sage. Chinese (seventeenth century).

does not know the dealer to be reasonably expert, it may be advisable to seek the opinion of a knowledgeable third party before completing a transaction. Incidentally, a receipt should always be obtained for purchases and this should state the approximate age and give a brief description of the article. No dealer worth his salt will refuse to give such a receipt, which is important should dispute arise later and also in the matter of insurance.

Where can a collector look for pleasing examples of western European ivories of the seventeenth and eighteenth centuries? Reading through sale catalogues will occasionally prove fruitful, but only occasionally will items likely to realise modest prices appear in a sale. Look anywhere and everywhere in metropolitan and provincial curio and antique shops. Continental ivories flowed into Britain without interruption in the seventeenth, eighteenth and nineteenth centuries, whether distributed by merchants or brought home by travellers. Even in recent years while the search has intensified, 'finds' have been made on country market stalls and at jumble sales. Too often bone is mistaken for ivory, but the reverse has been known. Never hesitate to enter an expensive-looking curio or antique shop where you think ivories may be included among the treasures on display – the prices may not be as shattering as you fear. Impressive non--specialist establishments do not invariably charge prodigious prices.

Alternatively, holidays in Europe can often prove fruitful to a collector if he explores the numerous curio and antique shops to

be found in most towns in western Europe; it goes without saying that old ivories are on the whole more commonly on sale in Continental establishments than in Britain. Since the end of World War II Americans who appreciate the beauty of ivory have discovered the attractions of European ivories and carried home many fine examples acquired during their travels.

Finally, yet a further word of warning. An enthusiastic collector lighting upon a handsome antique ivory in an out-of-the-way place during his travels abroad should act with the utmost caution, particularly if the price is unexpectedly low. Deception and fraud in *objets d'art* is not confined to any one country, and all items offered, whether as 'bargains' or not, should be carefully scrutinised.

The objects made from ivory in western Europe during the seventeenth and eighteenth centuries were principally:

Crucifixes, rosaries, goblets, beer mugs, tankards, hunting flasks, tobacco jars, portrait medallions, portrait busts and statuettes, game counters, needle cases, fans, knife, dagger, sword and cane handles, drawing instruments, pocket dials, pocket calculators, jewellery, cameos, copies of sculpture in reduced scale, terrestrial and celestial globes, diminutive carved figures and groups, boxes in great variety, religious statuettes, plaques, chess sets, balls-within-balls, scent bottles and bibelots.

6 Oriental Ivory Art

After the establishment of Islam the art of ivory carving developed in the Near East principally as a result of contact with Byzantium. Early Islamic ivory workers principally used walrus tusks (procured from the Arctic, via the river trading routes of Russia and Byzantium), and their techniques differed little from Byzantine practice. In Persia especially, ivory carvers attained a high degree of technical ability. Many craftsmen specialised in ivory inlay, using shaped pieces of plain or carved ivory in the creation of complex designs.

Although elephant ivory was easily obtained from African and Indian sources, and was much easier to work, ivory carvers in the Near East preferred to use walrus ivory, which in early times was much more highly valued. It was once credited with possessing magical and medicinal properties, with the power in particular to staunch the flow of blood, to heal wounds and to detect poison. For these reasons, knife, dagger and scimitar handles were frequently fashioned from ivory, as were spoons, many of them richly carved.

In order to demonstrate that the material used was truly walrus ivory, carvers developed a technique of carving deeply or splitting the piece to be worked into two sections, then placing the two outside surfaces together, thus displaying the inner surface or core.

These characteristics are to be noted in Islamic ivories of Near Eastern countries, although techniques employed, styles, and manner of decoration varied considerably between regions. It is therefore not usually difficult to distinguish the ivories of one area from another. For example, in Turkey craftsmen favoured geometrical patterns and arabesques, while the Egyptian Fatimid ivory workers created complex backgrounds against which human figures, winged lions and other animals often featured. In Persia, where the art of ivory carving developed to a degree unsurpassed elsewhere in Islam, characteristic designs featured somewhat rigid figures standing stiffly erect between pots of flowers or shrubs.

Islamic ivory workers also produced numerous objects devoid of carved decoration that relied upon the beauty of the material itself for rich effect or alternatively were painted and gilded. Boxes of all kinds were made, including jewel caskets, usually constructed from thinner sheets of ivory than were required for

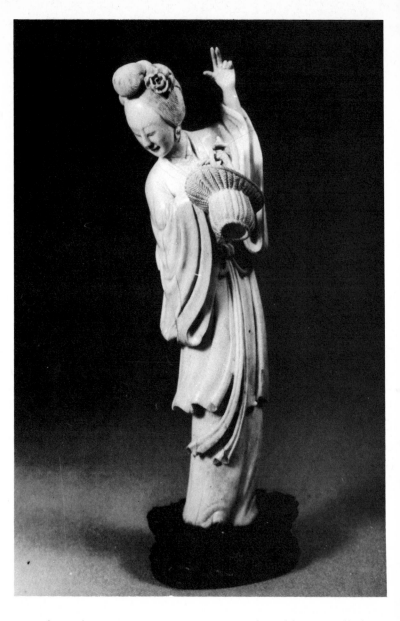

carved work. Painting was in green, red or blue, or all three
colours in contrast, the designs almost invariably outlined in
black. Gold, in either leaf or paint, was used sparingly by the best
artists, usually delicately applied. Among surviving early Near
Eastern decorated caskets few have retained more than a trace of
their original rich colouring.

Near Eastern craftsmen became adept in the use of ivory to
decorate furniture and the interiors of buildings. Panels which
have survived, dating mainly from the thirteenth and fourteenth

centuries, demonstrate both the techniques and style used. Designs usually comprise vegetable and geometric arabesques serving as a setting for stylised animals and birds. Islamic artisans developed an aptitude for inlaid work on doors, tables, reading desks and minbars (pulpits). Pieces of ivory used in intarsia might be plain or carved. Incrustation was always rich and highly decorative, the craftsman obviously relying upon intricate patterns composed of ivory to achieve a striking effect. Some Islamic designs in ivory inlay are too 'busy' to appeal to western taste and the arrangement of ivory pieces in intricate pattern may sometimes tend to dazzle. Nevertheless, the effect of the best work is one of beauty and harmony derived from the skilful combination of exotic woods and ivory.

During the period when the decorative art of Cairo became strongly influential in a large part of Islam, under the Mameluke dynasty in Egypt, plant motifs used in conjunction with effusive inscriptions were greatly favoured. Cairo ivory workers became renowned for their beautiful caskets, the majority of which bore inscriptions in Kufic or cursive script. These are comparable with the Hispano-Arabic ivory caskets referred to in an earlier chapter.

Egyptian craftsmen acquired great skill in wood intarsia in the decoration of doors, furniture and minbars, followed by the development of advanced techniques in the use of ivory for such inlay. They appear to have specialised in the production of ivory panels mostly finely carved with arabesques and bearing dedicatory inscriptions. For a period the Cairo style in ivory art was widely emulated in the Near East, but its pre-eminence was brief and proved to be merely a prelude to the general decline of the art of ivory carving in Islam. Despite this increasing degeneration in style and craftsmanship – even in Persia where a tradition of fine carving in ivory endured into modern times and indeed in some respects may be considered still to survive among small scattered groups of craftsmen – Islamic ivory carvers continued to produce innumerable ivory objects, many of which found their way to European markets. Fine Islamic carved ivory dagger and scimitar hilts, the best made during the sixteenth and seventeenth centuries, were esteemed for their beauty and excellent workmanship as far away as western Europe, where they realised high prices. Small pieces of ivory were used in the manufacture of toilet or household objects, boxes of various types, inkwells and spoons.

Indian Ivories

Ivory carving was an ancient art in India before the birth of Christianity. As a result of trade with Persia, walrus ivory was imported into north-western India where again it became more

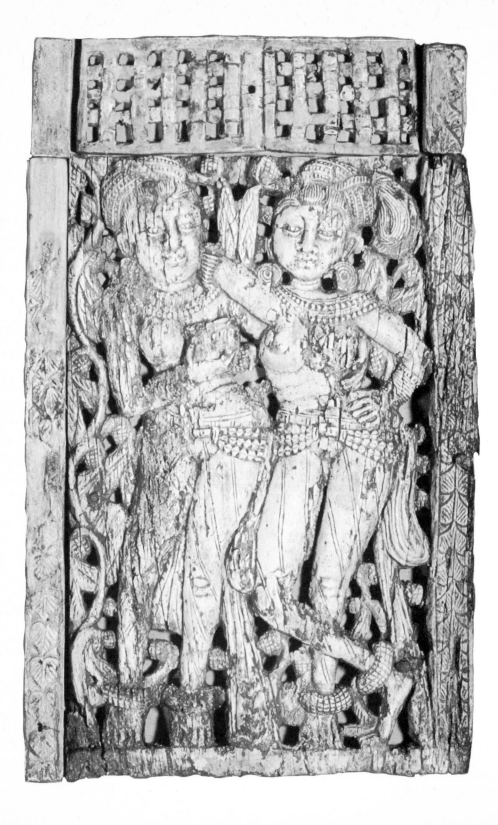

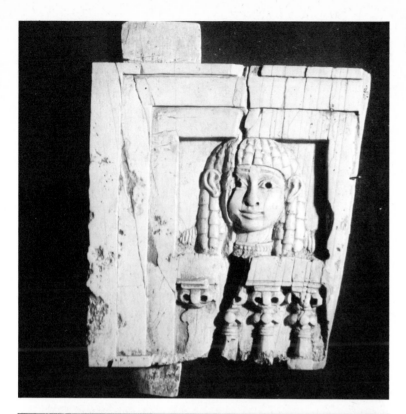

Opposite: Two goddesses – a 2nd century ivory carving from Begram in India

Above left: Phoenician ivory from the palace at Nimrud: the goddess Astarte in the guise of a sacred harlot, looking out of her window

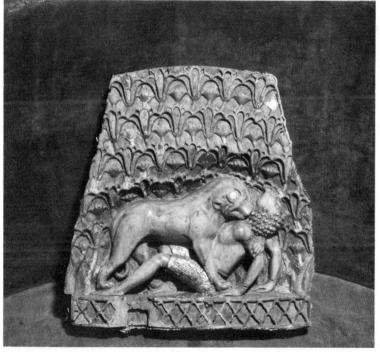

Below left: Another Nimrud ivory shows a lion eating a man

highly valued than elephant ivory for its imagined healing and magical properties. Evidence that ancient Indian ivory carvers developed notable technical and artistic skill materialised when a large number of ivory objects were brought to light during excavations at Taxila (Pakistan) early in the present century. It is now thought that some of these very early ivories may date from as remote a period as the second century BC. Some of them are entirely of native design and workmanship, others exhibit Greek or Near Eastern design elements, while others are almost certainly of foreign origin and were probably imported from the west, possibly from Roman sources. The Taxila finds consist principally of personal ornaments, toilet and household articles, and counters and other pieces used in playing games.

Before the discoveries at Taxila some authorities were inclined to believe that ivory carving was not a widely practised art in any part of India in very ancient times, and that the majority of ancient ivories found in India were of foreign origin or were local copies of ivories brought from regions to the north-west. It is now established beyond doubt that ivory-carvers' workshops were active in India long before the Christian era began in Europe, though the date of ancient ivories excavated at Indian sites can only be surmised. Most writers speculating on early ivory carving there now refer to the inscriptions on the south portal of the Great Stupa of Sanchi, dating from about the first century BC, which state that a group of ivory workers at Vidisa (Bhilsa) executed and presented the portal or torana. A well-known ivory figurine of ancient Indian workmanship was brought to light at Pompeii, a reminder of the trading and cultural contacts between India and the Roman empire. It is generally concluded, however, that ivory carving was non-Indian in origin, probably being first introduced into north-western India by Persians or even Europeans, such as the Greeks of Alexander the Great.

Excavations at Begram carried out in 1937 and in 1939-40 resulted in the discovery of ivory figures which threw new light on the later development of ivory art in northern India. Important finds were made when a walled-up room in the ancient royal palace was opened and relics of the Kushan dynasty were revealed. Besides artifacts of Greco-Roman origin, some ivories of indisputable Indian origin were found, believed to date from between the first and second centuries AD. Great interest was also aroused by the numerous plaques discovered. Ivory plaques were evidently used to ornament furniture, and since the carvings are mostly delicately executed, of feminine character and appeal, it is suggested that they were made for the decoration of furniture for women's apartments. Much of the carving on the figures and plaques, and the style of the figures themselves, bears affinity

with sculpture at Amaraviti and Mathura; but the decorative plaquettes, attached to wood with copper nails, indicate an original approach to design and manner of execution. While the scenes depicted on some of the plaques are unmistakably Indian in character, whether showing episodes from the life of the Buddha or secular activities, the decorative motifs occasionally appear to be of western origin or inspiration, perhaps Roman, or even earlier, as indicated by the inclusion of human faces and heads of animals similar to those depicted in Greek sculpture.

Three large Begram ivory female figures, each some twenty inches in height and carved in exceptionally high relief, each figure standing on a figure of a mythological marine animal (*makara*), have been identified as river goddesses.

The Begram ivories, divided between the Musée Guimet, Paris, and Kabul Museum, are representative of ancient Indian ivory carving at the peak of development before decadence led artists to forsake their early simple style in favour of over-embellishment. For a number of centuries, especially through the artistic Gupta period, Indian taste in ivory carving remained commendable and ivory work of all kinds appears to have been much admired. Orissa became noted for fine statuettes carved in northern Indian tradition. The finest traditions endured and techniques employed were in most respects the same in the eighteenth century as were followed at least a thousand years earlier. With the seventeenth century, however, though incised work and carving in low relief remained popular, ivory workers discovered the merits of the lathe and produced many turned ivories.

From the eighteenth century onwards Travancore became celebrated for brilliant work in ivory incrustation produced in the numerous workshops active in the region. The process entails first engraving the surface of the ivory, after which coloured lacquer is poured into the incisions. Scraping away surplus lacquer and polishing follows. The result is an extremely attractive coloured lacquer design appearing within the smooth surface of the ivory. Although of ancient origin and used widely in Travancore, especially in Tanjore, since the eighteenth century, also in Mysore and Ceylon, the technique is still practised with great skill by modern Indian ivory carvers. Tanjore musical instruments ornamented by the ivory and lacquer techniques are highly valued in India today.

Ivories produced in Mysore and Ceylon which during the eighteenth century showed the same purity of style and other characteristics of Travancore ivories, gradually degenerated and even before the beginning of the nineteenth century had lost much of their charm. This may be attributed to the execution of exaggerated relief in an endeavour to detach figures. At the same

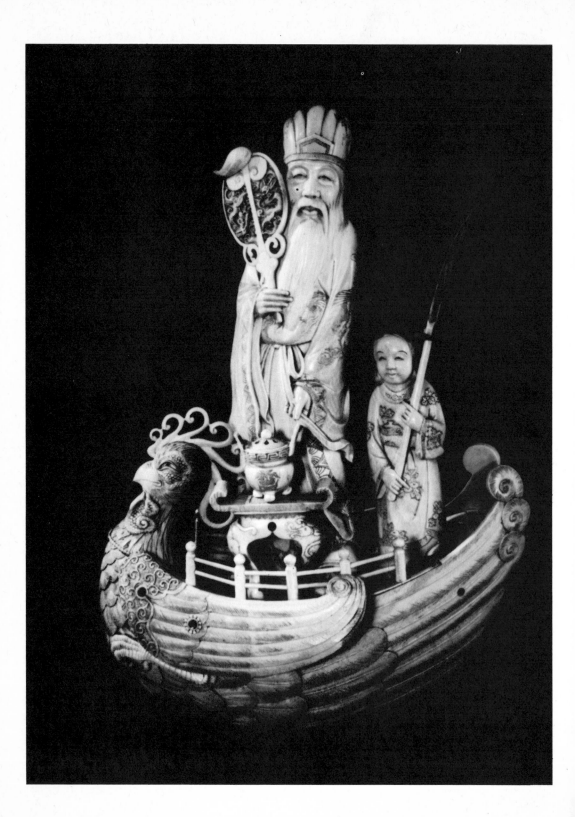

time an element of coarseness, even carelessness, crept into Sinhalese ivory sculpture, while its quality markedly diminished.

Goa, the prosperous Portuguese settlement on the west coast of India, became noted for the production of ivories. By the eighteenth century Goa had become a great ecclesiastical centre and missionary base, and religious statuettes were the principal productions of the Goanese ivory carvers, with rosaries, crucifixes and a few objects of secular usage. Ivory figures carved by native artists in Goa are not usually difficult to recognise, since although they have the general appearance of ivory religious figures carved in Europe during the seventeenth, eighteenth and nineteenth centuries (mainly comprising Madonnas, Good Shepherds, saints and Biblical characters), they are obviously non-European in cast of feature. Production increased enormously during the eighteenth century, but with a marked decline in the standard of workmanship. This varied greatly, however; specially commissioned objects carved by a master, even a Goanese master ivory carver, were often splendid pieces. Unfortunately innumerable ivories of indifferent workmanship were also shipped to Portugal, where they were readily bought by the deeply religious Portuguese and are still to be found.

Finally, in briefly surveying the development of ivory art in India, mention needs to be made of a series of ivory female and animal figures believed to have been produced at Rajasthan or Malwa in about the eleventh century AD or possibly a little earlier. It is known that workshops were active in the region at the period. Ivories were also carved in the Deccan. In South India carving in ivory advanced in skill and popularity from the late seventeenth century onwards and has continued as a native craft into modern times.

India was also celebrated for its ivory chess sets. Little is known concerning the magnificent sets made in early times for playing the ancient game *chaturanga*; most of the fine Indian ivory chess sets known to or acquired by Europeans were made from the late eighteenth century onwards, and will be referred to in the next chapter.

Chinese Ivories

In China it is characteristic of all fine art that techniques and styles continued unchanged through many successive generations, often rendering correct attribution and dating a difficult matter. Identical materials were used over long periods, the work of artists in one century often appearing little different from that of artists several centuries earlier or later. This is especially true of carving from African ivory, for the material changes colour only slightly over many years. Indian elephant ivory, much used in ancient China, is at first more densely white but yellows much

more rapidly, so the actual colour of objects made from it often provides a clue to the approximate date of production. Even so, dating Chinese ivories demands extreme caution.

The art of ivory carving in China extends far back into the remote past — possibly 4,000 years — and Chinese carvers may have been the first civilised men to work in ivory. As in Europe, where ivory has also been carved for thousands of years, considering the vast quantities of ivories that have been produced in China it appears strange that such a comparatively small number of ancient examples has survived: for ivory was always a costly — and durable — material, and the works of artists were treasured and handed down in a family. However, sufficient ivories survive in public and private collections to establish that the skill of Chinese ivory carvers in past centuries was inferior to none.

The Chinese were accustomed to working in walrus ivory as early as the T'ang dynasty: as in the Near East in early Islamic times, it was thought to have magical qualities. Ivory carving was carried on fairly extensively under the Shang dynasty (c 1523-1028 BC), demonstrated by ivories, chiefly pail-shaped vessels probably used in religious ceremonial, and pendants in the shape of fish, brought to light during excavations at An-yang, which is believed to have been the Shang capital. Ivory was regarded as a precious material under the Chou dynasty (c 1122-249 BC) that succeeded the Shang, although scarcely any Chou ivories survive beyond a few questionable examples that convey little idea of the high level of technical ability which the carvers probably attained. By that early date, Chinese artists were already not content simply to ornament ivory with carving but also stained, painted and lacquered the surface. Ivory was sometimes inlaid with coloured stone or encrusted with turquoise. The Chinese appreciated the qualities of ivory, particularly as an easily worked material, but through successive centuries preferred at times almost completely to conceal the beautiful natural-coloured surface with colouring or incrustation.

The Yangtze river delta area became a flourishing ivory-carving region, especially within the borders of the state of Ch'u situated along the winding banks of the river and extending southwards. Elephants, which were indigenous to China and roamed wild in some areas until about the second century BC, had by that time been driven southwards with the result that the inhabitants of Ch'u lived well by trading in ivory.

It is not certain when ivory memorandum tablets worn suspended from the girdle first appeared. Princes and high officials wore them at the Chou court as a symbol of exalted rank, and that they were made from ivory attests to the esteem in which it was held. The *hu*, a carved ivory staff or baton carried by persons of high rank, was adopted as an essential item of for-

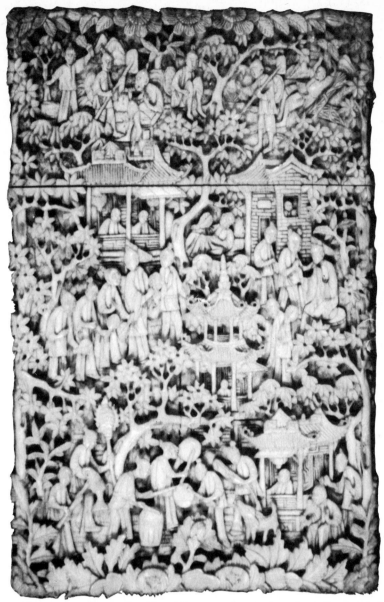

mal court attire under the Chou, and continued to be carried by high-ranking officials and dignitaries through successive dynasties. At the T'ang and Sung imperial courts the ivory tablets became gradually more elongated and served both as a staff and as writing tablets. Some were made over a foot in length, richly carved, following the natural curve and tapering form of the tusk. Court officials and persons of rank carried *hu* until the end of the Ming dynasty.

Under the Han dynasty (c 206BC-AD220) Chinese ivory carving achieved a hitherto unprecedented beauty and refinement.

Certain localities such as Yang-chou and Ching-chou became noted for the production of finely carved ivory objects. While the traditions of Chinese ivory art were in the process of evolution during early dynasties, ivories were imported from India, even from sources as far distant as Rome, and no doubt Chinese ivory workers learned from studying the techniques of foreign craftsmen.

With the establishment of the T'ang dynasty (AD618-906), China entered upon a golden age of fine arts. Although regrettably few authenticated Chinese ivories dating from the period have survived there are sufficient to provide evidence of superb artistry and advanced technical ability. At the opening of the T'ang era ivory was becoming increasingly popular among the Chinese, not principally for ceremonial objects and religious sculpture as hitherto, but also as a material from which articles of luxury were produced for wealthier classes who could afford to commission them. Literary evidence supports the theory that under the T'ang the art of carving in ivory made greater technical and artistic advancement than during any previous dynasty; the precious T'ang ivory sculptures preserved since 752 in the Shosoin art storehouse, the ancient imperial treasury in Japan, leave no doubt of this. When the Great Buddha at Nara, Japan, was dedicated in 752, a number of finely executed ivory figures were sent from China as gifts; these were afterwards placed in the Shosoin where they have remained ever since.

Indian and Near Eastern elements may be noted in T'ang art, but the influence of European art styles is also evident, though in more subtle form. Trade connections with Byzantium and cities of the Near East probably led to an interchange of artistic ideas, and the influence of western art upon T'ang ivory carvers may be more profound than at first thought. The artists faithfully followed certain ancient traditions, however, whatever the extent of their interest in foreign art. For example, they did not resort to deep undercutting in the production of figures, preferring to create in flat pieces, first stained or painted, then carved in the most complex manner. A considerable amount of colouring was used in the embellishment of carved representations of animals and birds, but it was not uncommon to leave the ivory free from stain or paint, Blue and red were favoured for colouring carved objects. *Po-lou* was another decorative technique. It was practised only by the most accomplished T'ang craftsmen, and consisted of engraving designs on a dyed ivory surface, so that only the carved areas were left in the natural colour of the material. All openwork and relief carving was executed with painstaking care; and an ivory worker needed to be exceptionally skilled before undertaking the insertion of ivory veneer into the surface of articles made from some other material. The T'ang workers were

exceptionally versatile, exhibiting great accomplishment in producing objects composed entirely of ivory or of ivory combined with other materials, delicately inlaying wood with ivory or producing elaborately ornamented furniture and boxes. In imperial workshops set up under the T'ang emperors, the finest ivory carvers made a wide range of items for the personal use of the emperor and members of his court or for the adornment of their homes. Ivory tusks were probably obtained from Burma and Annam, although certain authorities believe that elephants were bred in China under the T'ang dynasty.

Ivory remained almost as popular through the Sung period. Both elephant and walrus ivory was imported from countries to the west of China but in lesser quantity from adjacent India than from Arabia and Persia where ivory traders were very active. Sung ivory carvers inherited their skills from their T'ang predecessors, especially in exquisite inlaid work on furniture and caskets. One of the most celebrated master carvers in ivory during the Sung period was Wang Liu-chiu, who specialised in carving ivory covers for Buddhist scriptures and religious figures. Ivory objects that can be assigned to the Sung dynasty with certainty are rare. Outside China a few carved figures are believed to date from the Sung period; these can be thus ascribed on points of carving technique and style, but with no absolute certainty.

The names of several celebrated ivory carvers at work under the Sung and Ming dynasties have come down to us, among the most accomplished being Chu Hsiao-sung, Chu Lung-chu'an and Fang Ku-lin. These artists undoubtedly worked in well-established traditions from which through many generations Chinese ivory carvers showed little inclination to deviate.

In colouring ivory and stone sculpture the Sung artists followed T'ang tradition, but with certain important changes in technique. The T'ang ivory figures preserved in the Shosoin at Nara were coloured with an opaque medium, giving a solid effect, but colouring employed in the embellishment of Sung ivory sculpture was a stain rather than a paint. Sung ivory workers are known to have been inventive craftsmen, gifted with lively imagination and great mastery of design and form. Their ivory sculpture is recorded as having been extremely beautiful, executed with skill exceeding even that of T'ang artists. Whatever they made from ivory, game pieces, sword scabbards, knife hilts, plectrums for use on stringed musical instruments, seal boxes, folding fans, chopsticks or incense cases, all richly carved with animals and birds, carving of buildings or landscapes, often coloured red and blue, or in both colours gaily contrasted, the Sung ivory craftsmen worked with precision and care, maintaining the same high standard of execution in the making of a simple object of everyday use as when creating a figure to grace a

palace or temple.

When the elephant no longer roamed wild in China, ivory had to be brought from distant places. As already noted, the scarcity of ivory within China's borders became acute during the Sung dynasty. Elephants, greatly reduced in number, retreated south-westwards into the wild areas of Nanchao, then an independent kingdom (modern Yunnan), and mainly by reason of continually diminishing herds and reluctance on the part of the inhabitants of Nanchao to send a sufficient supply of tusks, the Chinese had to look towards more distant sources. Eventually a trading connection was established with Arab ivory traders at Zanzibar who were the first to ship ivory tusks to China.

When the Sung dynasty collapsed before the onslaught of Kublai Khan's all-conquering army, which swept down from the north, and the Mongol dynasty was established, the art of ivory carving in China continued more extensively. The Great Khan, as Marco Polo referred to him, kept a huge number of elephants in captivity, many of which were presented in tribute to the conqueror. From contemporary accounts of the luxurious court of Kublai Khan there can be little doubt that ivory was used on a lavish scale in the production of ornaments, articles for personal and household use and in the embellishment of furnishings and the interiors of buildings.

When in 1368 the native Ming dynasty (1368-1644) began to rule China, a great revival of arts and crafts took place under imperial patronage. Ivory carvers were encouraged to produce fine works for the adornment of palaces, private homes and temples. The best ivories were produced at Fukien which became celebrated for its workshops. Regrettably few examples of Ming ivory carving have survived but in carved figures of Lohan (disciples of Buddha) and figures portraying the Buddha himself we may at once perceive the remarkable skill and sensitive execution which characterise it. It appears that in sculpture Ming ivory carvers attained the zenith of their powers of artistic expression and technical expertise. A signficant change was that ivory was left in its natural colour, free of paint or stain. These, probably the first Chinese ivory figures to be left uncoloured, since on most ivory sculpture believed to date from earlier dynasties traces of paint or stain can be detected, are serenely beautiful. The passage of time has mellowed the ivory and the figures possess charm, grace and refinement rarely found in later Chinese ivory sculpture. Ming ivory statuettes were subsequently often copied — a point collectors may well bear in mind.

China was fortunate in that the second emperor of the Ch'ing dynasty (1644-1912), K'ang Hsi, was a passionate lover of fine art. In 1680 he set up workshops for artistic production in the grounds of the Summer Palace at Peking, assembling the most

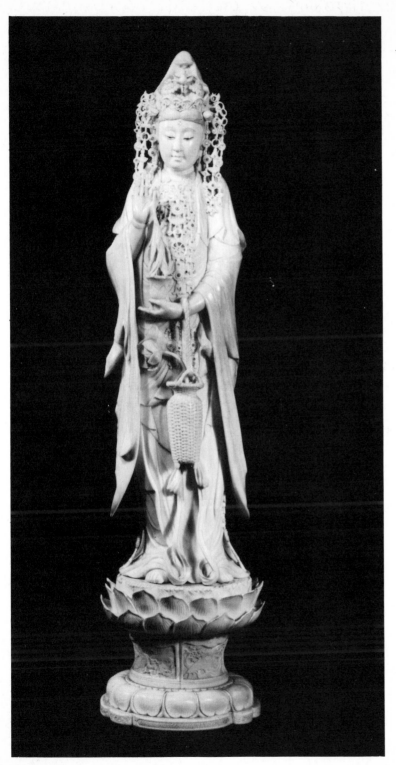

Kwannon, very finely executed
and signed 'Nobusada' on base.
Japanese.

skilful and artistically gifted craftsmen in China. It was K'ang Hsi's intention that all works of art produced in the imperial factories should be executed in the Chinese tradition and that no foreign elements or styles should be incorporated. The emperor was primarily concerned with the revival and perpetuation of the true native arts of China, and to a great extent, so far as the products of the imperial factories during his reign were concerned, his object was achieved. Over a period of about a hundred years some of the finest Chinese works of art ever conceived were produced there. Ivory carvers were active in their own special workshop which the emperor often visited, to supervise and encourage production. K'ang Hsi evidently shared the enthusiasm of many of his predecessors in his admiration for fine ivory carving.

Although the imperial workshops were virtually inactive in the latter years of the reign of Ch'ien Lung (1736-96), ivory carving was carried on in a number of localities where old traditions and craftsmanship survived. Perhaps the most famous and beautiful productions of Ch'ien Lung ivory workers are the delicately tinted figures that rank among the world's masterpieces in ivory. Chinese connoisseurs, and others far distant from China, share the opinion that Ch'ien Lung tinted ivory figures are the most exquisite objects ever produced by Chinese ivory carvers. Both stain and lacquer were used in the colouring process. There was also a revived taste for coating the surface of ivory with opaque lacquer by the technique practised among T'ang ivory workers.

A few names of ivory carvers celebrated for their fine productions during the reigns of K'ang Hsi and Ch'ien Lung are known from literary sources. Tu Shih-yuan and Wu Feng-tsu worked under the patronage of K'ang Hsi. Notable ivory carvers in Ch'ien Lung's reign included Li Te-Kuang, Chu Hung-chin and Ch'en Yang-shan.

Collectors should note that northern Chinese ivory carvers occasionally signed and dated their works, generally using their assumed studio name. Furthermore, it may not be mere chance that all the known Chinese master carvers in ivory up to the end of Ch'ien Lung's reign were natives of or worked in northern China. Where ivory was once plentiful, in the Yangtze river delta, workshops sprang up and craftsmen attained a high level of proficiency. Some of China's greatest ivory carvers employed at the imperial court learned their craft during their early years in the Yangtze delta region.

From Peking until about 1780 and in workshops in other cities to the end of Ch'ien Lung's reign, there issued a steady flow of ivory objects made expressly for the emperor and members of his court or for the privileged wealthy upper classes. Scent bottles,

religious figures, fan handles, cylindrical brush boxes, armrests carved in high relief on the lower concave side and in flat relief on the upper convex surface, table and folding screens, staffs, snuff boxes, perfume boxes, articles for feminine use such as combs, hairpins and hair ornaments, mirror cases, opium pipes, stands for wine cups and porcelain ornaments were all exquisitely carved with an extraordinary variety of motifs, floral, geometrical and symbolic. Many larger articles were ornamented with carved landscapes, scenes with buildings or with figures of people engaged in work or play, birds, animals and fish. Carving varied in execution, in relief, in open work or intricate line engraving. A complex technique known as *lou-k'ung* evolved, in which the artist used his tool in such a manner that the cutting produced an illusory effect of a carved object within a concavity.

Collectors will occasionally come across small ivory figures of nude women in a reclining position. Less often, the figures wear light garments. These are sometimes referred to as 'medical ivories' and were used by upper-class Chinese women when consulting a doctor. The figures served as a substitute for the body when indicating symptoms.

Canton was the second most important ivory-carving centre in China. It also became the principal production centre in the chess-set industry which developed in China early in the nineteenth century. As far as most western collectors need concern themselves, Chinese ivory chess sets belong to the nineteenth century and will therefore be considered in the following chapter together with the art of the Cantonese ivory workers generally.

Concentric balls, one within the other, sometimes exceeding ten in number, ingeniously carved from a solid piece of ivory, are probably the most familiar and fantastic objects made by Chinese carvers seen in the western world. These are known as *tao-ch'iu*. Each ball is decorated with the openwork of a different pattern. These began with carving a single ball and piercing a series of holes through it towards the centre. When the carver succeeded in working his cutting tool sufficiently far in to carve the central sphere he proceeded to carve successively larger balls by working outwards until all the spheres were completed within the ball originally carved from the single block of ivory.

Miniature sets of concentric balls, usually with about three interior balls, are sometimes found fitted into the bases of chess sets.

The theory that the Chinese art of carving concentric balls evolved several centuries ago, possibly during the fourteenth century, is conjecture. Of the many old sets extant it is doubtful if any date back more than a century. The majority are considered to be productions of the late nineteenth and early twentieth-century craftsmen, made especially for the tourist and export markets at a period when Chinese ivories were greatly in demand

by westerners. In China, however, there may survive sets of considerably greater age.

Mention has been made in an earlier chapter that German ivory carvers produced sets of concentric balls following the Chinese technique. A comparison of examples will be found interesting.

Japanese Ivories

A thousand years elapsed between the early first phase of Japanese ivory art and its full flowering during the late eighteenth to mid-nineteenth centuries. It is inexplicable that after the eighth century, when Japanese craftsmen imitated the Chinese in the creation of beautiful ivory objects, little more carving of merit appears to have been produced until the later eighteenth century. A craft in which the ancient Japanese doubtless excelled was apparently abandoned for ten centuries.

Ivory is believed to have first been carved in Japan when the aristocracy began to copy the T'ang culture of China, in the eighth century. Always swift to imitate, and possessing a rare talent doing so, the Japanese no doubt lost little time in endeavouring to reproduce the ivory objects that reached their country from China. The first ivory tusks used by Japanese carvers were probably obtained from China. So well did the Japanese craftsmen learn, developing a mastery of the medium equal to that of their tutors, that it is practically impossible to distinguish between ancient ivories carved in Japan and in China. Ivories preserved in the Shosoin treasury at Nara certainly include T'ang productions, but other work may well have come from the hands of ancient Japanese carvers. Similarly, ancient ivories which grace the Horyuji temple, Japan's oldest wooden structure, are assigned to either Japanese or Chinese artists according to the individual opinion of experts.

The Chinese custom for high officials and personages of rank to carry a ceremonial baton or staff (known as a *hu* in China) was adopted among noblemen and court officials in Japan. The *shaku*, as it was known in Japan, was frequently made of ivory, usually left in its natural state and uncarved.

Bachiru, a decorative technique which originated in China, became very popular in Japan and was widely used in the embellishment of ivories. A design was engraved on the surface of the ivory after it had been stained red or green. Colouring had to be applied in a special way to ensure that the carved design would stand out in contrast against the surface of the ivory. More rarely, objects were fashioned with both the carved design and the rest of the ivory surface decorated in contrasting colours. Inlay was an art in which Japanese ivory workers excelled even in the early period. Pieces of ivory were cut to shape and inset in

arabesque patterns, or in geometrical designs composed of curves and lines, on boxes, furniture and musical instruments. From a few examples surviving in the Shosoin it appears that Japanese ivory carvers also learned to carve in the round.

But for lack of surviving examples — except a precious few preserved in Japan which may in a final judgement be proved not to be Japanese but Chinese — the early ivory art of Japan is obscured by the mist of time. A dependable, practical assessment of Japanese achievement in the art of ivory carving must rest upon works executed a thousand years later during a remarkable renaissance of creative art.

Japanese ivories of the Tokugawa period (1603-1867), more especially the works produced during the second half of the eighteenth century and the first half of the nineteenth century, demonstrate an astonishing development of technical and artistic skill among artists who at first emulated Chinese traditions but gradually evolved their own individual techniques and styles. At first production was centred in Kyoto, but later the most important workshops were situated in Tokyo after it became the new capital. Some ivory carvers achieved great repute; the works of artists such as Ogasawara Issai, who was active in the late eighteenth century, were intensely admired and much sought

Left: Handaka Sonja fine carving. *Right:* Okimono in the form of three immortals, two male and one female, seated in a large *sake* cup and signed 'Yasuhide'. Both Japanese.

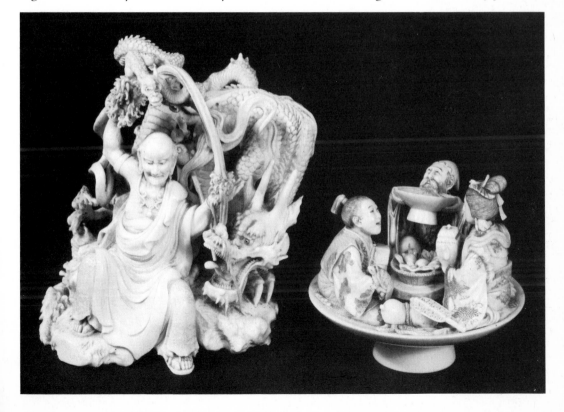

after even during their lifetime.

As the demand for articles made from ivory increased, growing numbers of craftsmen, employed in groups or in their own independent workshops, were engaged in the production of utilitarian objects or concentrating upon producing ornaments. Perhaps output was most prolific in *netsukes,* probably the most universally familiar and admired Japanese objects sought by collectors of oriental ivories. In the carving of these diminutive works of art, necessitating working with incredible dexterity on a microscopic scale, the Japanese ivory carvers displayed unsurpassed mastery of technique. Readers are referred to Chapter VII for information on them.

Collecting Oriental Ivories

Whether or not a specialised collection of oriental ivories is desired, a study of the techniques and productions of eastern ivory carvers is highly relevant to acquiring knowledge of the art of ivory carving generally.

Genuine old ivories produced in Islamic countries of the Near East are not common; indeed they are only rarely offered on the market and are then expensive. Reproductions of old ivories have been made in Near Eastern workshops since the beginning of the present century when interest in ivories revived, and copying still goes on. Fortunately for the inexpert collector, comparatively few imitations appear to have reached western European markets. Some of them are very deceptive at first glance and, seen in a dim light, would almost certainly be mistaken for the genuine article by the inexpert and even momentarily by a practised eye. Anyone offered an 'ancient' ivory of Near Eastern provenance should examine it closely.

With Indian ivories the position is different, and in certain respects the collector is on safer ground. At all events, the prospect of finding interesting worthwhile examples is brighter, and usually without too much exausting effort. There is also much more likelihood of tracking down good pieces for which exorbitant prices are not demanded. Due to a close relationship with India over the past three centuries or so, Britain is still a rich hunting ground for collectors of Indian antiquities and works of art. As already seen, a fashion for Indian ornaments, jewellery and *objets d'art* of all kinds prevailed in Britain during the Victorian era and such items arrived at British ports in large consignments, or were brought back by travellers, servicemen, missionaries and members of the vast administrative network.

By no means all the ivories sent to Britain by way of trade or carried home as souvenirs were of high quality nor classifiable as works of art. Some atrociously ugly objects carved by inept craftsmen found places as objects of curiosity. On the whole,

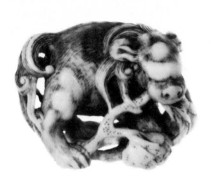

however, Indian ivory carvers working in the first half of the nineteenth century generally produced pleasing if not superb ivories. It is these, not the rare ivories produced in earlier centuries for the adornment of palaces and temples, or the costly chess sets and other articles commissioned by wealthy Britons while resident in India, that today's collectors with only modest amounts to spend can find and purchase. More about them, and their present interest and value to collectors, can be found in the following chapter.

Chinese and Japanese ivories present a special, somewhat complex field of study for the serious collector who may easily devote a lifetime to acquiring an expert knowledge of, say, Ch'-ing ivory art, or to becoming an authority on Japanese *netsukes*. Chinese ivory carving has a history that possibly goes back 4,000 years, and notwithstanding documentary evidence recorded in China in the past, and extensive research by modern authorities, there are many gaps in our knowledge of its historical development. The Japanese art of *netsuke* carving in ivory did not evolve until the later eighteenth century, and otherwise the development of ivory carving during the Tokugawa period presents few mysteries. As objects made in the remote first phase of ivory carving in Japan are extremely rare there is little point in advising collectors to pursue them.

Chinese ivories of earlier date than the late eighteenth century have become costly indeed, and even Japanese ivories dating from the first half of the nineteenth century command ever-increasing prices. Demands for Chinese and Japanese ivories of comparatively late date, now regarded as 'collectable', have set a price rise in motion; these, are ivories made in the early decades of the twentieth century are now attracting attention. As an encouragement to those considering collecting such items – and, in-

cidentally, their investment potential should not be overlooked – many Chinese and Japanese ivories made during the present century are of excellent workmanship and carved in fine taste from the best quality ivory. Further comment on the possibilities of collecting these follows at the end of the next chapter.

Specialists in oriental works of art with establishments in one or other of the world's art and antiques dealing centres usually have fine ivories to offer – at a price – and their advice is invaluable. Collectors obliged to keep a curb on expenditure must conduct their search in other quarters.

Having once gained, above all, sufficient practical knowledge and expertise to be able to recognise a genuine old ivory, the collector can safely direct his search away from the beaten track. Town and country markets, auction sales, house-contents disposal, small curio and antique shops may yield a surprising harvest. Whether the search extends across Europe, America or Asia, oriental ivories have become distributed throughout the world and may be discovered in the most improbable places.

7 Ivories of the 19th and 20th Centuries

Throughout the nineteenth century, especially during the Victorian age, ivory was popular in Britain, in most western European countries and in the USA, being used in every imaginable way for both utilitarian and ornamental objects. Even some children's toys incorporated ivory. Ivory chess sets began to be imported into European countries from the Far East in increasing numbers, although this did not deter western ivory carvers from producing both magnificent and indifferently carved sets that found a ready sale in their country of origin.

British Victorian Ivories

The British ivory industry was at the period divided into two sections: either utilitarian — making such items as cutlery handles, piano keys, surgical instruments and so on — or artistic, allowing talented professional carvers opportunity to create beautiful objects of ornamental character such as statuettes, crucifixes, boxes, curios, etc. Many specially trained carvers devoted their skill to the creation of exquisite ivory jewellery that became highly fashionable in Britain and on the Continent at about mid-century.

Collectors of Victorian ivory jewellery will discover at the outset that it falls into two categories. Ivory was combined with the precious metals used in jewellery or it served as the basic material, engraved, inlaid, carved or encrusted with precious or semi-precious stones, from which necklaces, bracelets, brooches, earrings and rings were made. At the commencement of Queen Victoria's reign, when ivory jewellery began to be worn by fashionable Englishwomen, pieces were usually small and unobtrusive. By the mid-1860s, when its popularity reached its zenith, craftsmen following the taste of the day produced extremely ornate ivory jewellery, intricately carved and inlaid with precious metals and stones in a manner considered vulgar by a later generation. Carved representations of animals, particularly the elephant, appeared on massive brooches, while necklaces might be composed of beautifully carved flowerheads strung out on thick gold chains. In the late 1860s when jet was in favour it became fashionable to wear jewellery composed of jet and ivory. Late in the century 'filigree' ivory jewellery became extremely popular. Continental ivory jewellery was extensively imported into Britain.

The Great Exhibition of 1851 gave impetus to the ivory-carving industry. Continental manufacturing concerns who displayed their ivory products in competition with British wares discovered for the first time that the craftsmen of London, Birmingham and Sheffield, the principal English ivory-carving centres, had developed remarkable skill and were as proficient and artistic as German, French or Italian carvers. On the whole the ivory productions of English craftsmen during the second half of the nineteenth century showed greater restraint in their ornamentation than Continental products of the same period. In classifying nineteenth-century ivories it is sometimes impossible to distinguish between British and Continental productions; virtually the same techniques were employed in all western European countries. But sometimes less elaborate decoration and simpler style may indicate British origin, and Continental ivories were often of less conventional character. These points cannot be accepted as a guide, however, as many exceptions could be found; British carvers could be guilty of over-elaboration or bizarre forms and patterns on occasion.

As the century progressed British ivory workers made increasing use of turning and engraving, the latter at that period being known as chasing. Ivory chasers were a specialist class of tradesmen, chiefly centred in the Sheffield area. The turners, who usually earned considerable wages on a piecework basis, principally found employment in Birmingham and London where large ivory concerns were situated. Numbers of turners worked ivory in their own small workshops supplying the orders of firms with whom they established a connection

Not to be outdone by the French and Germans, during the first half of the nineteenth century British ivory carvers became interested in the production of chess sets but at best, at least until mid-century, this was only a sideline for them. Possibly like the Flemish, the English carvers felt that both they and the ivory itself should be employed on finer wares. Nevertheless, chess pieces of formal design, surmounted with portrait busts of military, political and celebrated foreign personages, began to issue from the more enterprising workshops. A number of leading British manufacturers were making them by the 1850s, by which time the game had greatly increased in popularity in England.

Victorian parasol handles fashioned from ivory are now sought after by collectors. On the Continent and in Britain some exceptionally attractive handles appeared carved in an amazing variety of patterns. Sometimes the parasol stem was made entirely from ivory, terminating in a finely turned finial. Elaborately conceived ivory parasol handles were occasionally inlaid with gold in 'lacy' patterns, or exquisitely decorated with enamels;

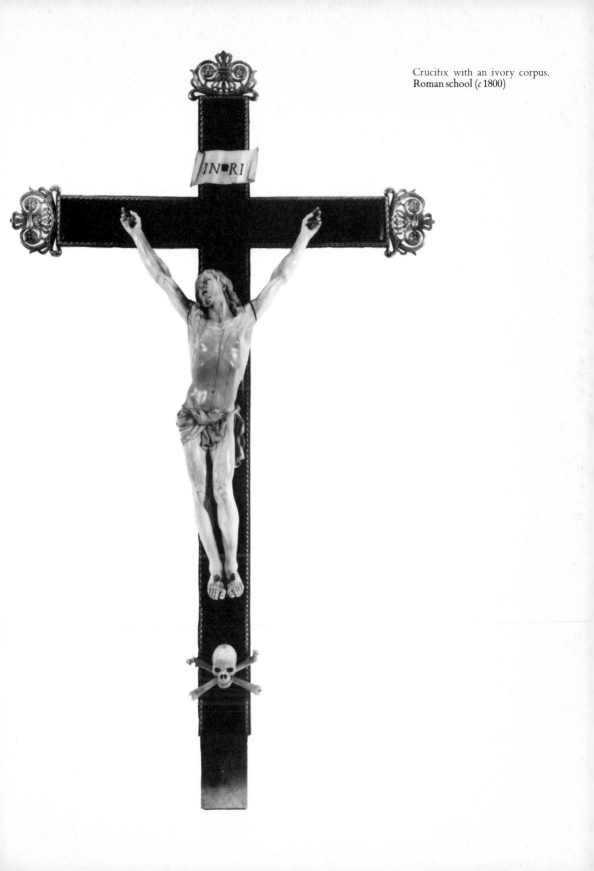

Crucifix with an ivory corpus.
Roman school (*c* 1800)

where cost was of no great concern they might be enriched with both.

The fashion for displaying portrait busts which developed in the early Victorian period helped to popularise the work of ivory sculptors, who generally received commissions through jewellers, goldsmiths and silversmiths. After Benjamin Cheverton invented his carving machine, which enabled miniature reproductions of famous statuary to be produced on a commercial scale, ivory busts, statuary and elaborate bas-reliefs became immensely popular as ornaments for the home. No mid-Victorian drawing-room with pretensions to elegance was considered to be *à la mode* without busts and statuettes. These were commonly made of parian ware, but those able to afford the finest often preferred ivory – which left visitors in no doubt of their wealth.

France: quantity versus quality

Much the same kind of ivory work was produced in France throughout the nineteenth century, though the rate of production was probably higher and increased in greater proportion as the century passed. Possibly the British ivory carvers took their work more seriously or disdained to produce trivial items devoid of artistic merit. But the French carvers had no hesitation about catering to popular demand, for example, turning out ivory novelties and curios for the souvenir trade in enormous quantity.

After the cessation of the Napoleonic wars, Dieppe's ivory industry rapidly expanded, including both small and large concerns. A large proportion of the output was exported. Ivories made in Dieppe or Paris were acquired as souvenirs by British travellers in France or were exported to Britain in bulk. It has already been mentioned that quantities of eighteenth-century French ivories found their way into Britain, and the flow of French products vastly increased in the nineteenth century – statuettes, rosaries and crucifixes, snuff boxes, chess sets, jewellery, and innumerable other items of somewhat inferior workmanship and material designed to meet the demands of a cheaper market. After the French Revolution ivory workers in Dieppe became more concerned with the volume of production and profit and in consequence the quality of their wares declined.

The French reputation for turning out fine chess sets was however maintained by talented craftsmen who seemed unaffected by the general decline. Pieces portraying Napoleon and Josephine, French marshals and soldiers, George III and Queen Charlotte, Wellington and British dragoons, all involved in the Anglo-French military and political struggle, will probably be familiar to collectors interested in old chesspieces. These principally date from the first quarter of the nineteenth century, the

best being made in Dieppe and Paris. At mid-century French ivory craftsmen were producing truly magnificent chess sets, faultless in material and workmanship, carved from the finest African elephant ivory. Usually the pieces for one player were left in the natural state while those for the other were stained red, though this arrangement was occasionally varied. Numbers of these superior sets are still in existence complete, and part sets are come across from time to time: they often portray historical episodes, royal personages of various European countries and battle scenes.

German Ivories Decline

The German tradition in ivory carving, which reached its peak of excellence during the eighteenth century, was kept very much alive throughout the nineteenth century and has survived into our own time. During the nineteenth century, however, as in the rest of Western Europe, artistic standards declined. Flamboyance mars what would otherwise now be regarded as fine works of art. Turning to the work of the present century, the Odenwald district of southern Germany and flourishing ivory-carving centres at Hamburg deserve special mention. As already seen, the Odenwald tradition of ivory carving may have survived from Roman times. Present-day carvers chiefly work for the tourist trade, supplying jewellery such as earrings, brooches and necklaces – ivory beads are a speciality – and very attractive animal figures. Odenwald workshops have acquired a reputation for exquisite inlaid work. Since the end of World War II Hamburg has made chess sets, religious items and fine reproductions of early ivories, some of the latter being very deceptive indeed.

Flemish Ivories

The Flemish were also active in the nineteenth century following their ancient tradition and producing a great amount of work imitating earlier styles. Flemish taste showed marked preference for detail and profuse ornamentation. The majority of pieces, especially religious items, were richly carved, and with large objects the effect could be somewhat overpowering and even repellent. Nevertheless, the Flemish were extremely versatile and talented, and their ivories were not usually more flamboyant in taste than those made generally in western Europe at the same period.

Recent Indian Ivories

The flood of Indian ivories that poured into Britain during the second half of the nineteenth century has already been commented upon. Quality greatly varied. As a rule, ivories made for wealthy British residents and Indians who commissioned them

from native carvers were of a superior workmanship and finer material to those hurriedly executed for export to Europe. Indian ivory carvers did not deviate from ancient tradition in the nineteenth century, although styles tended to become vulgarised as taste grew more decadent. But even here, the home of the elephant, ivory was never so plentiful or easy to procure that it ceased to be regarded as a precious material. Indian carvers had some techniques of their own: in the past, as today, they would contrive to soften the material before working by leaving it wrapped in wet cloths for up to a week. And for economy's sake, a tusk was frequently split into sections, and both concave and convex carved pieces were produced.

Less accomplished workers, who did not discriminate in selecting material, imitated highly skilled carvers in the type of objects produced. For example, with religious statuettes, numerous versions of the same figure may be found varying from the extremely fine to crude imitations. Other objects too may bear a superficial resemblance or even appear identical at a glance, but examination soon shows whether or not the workmanship and finish are all that is desired; the use of poor-quality ivory is also often evident.

Carving by hand was usual in Indian ivory workshops during the nineteenth century when native carvers were hardly progressive and foreign influence was slight. In the twentieth century, however, extensive use is made of the lathe in turned work. Since the early 1900s a considerable amount of Indian ivories have been coloured. It depends upon individual taste whether or not their attraction is increased by such embellishment: the majority of collectors think that ivory is best left with its natural colouring. Early in the twentieth century Hyderabad became a centre for the production of distinctive, quite tastefully coloured ivories, usually dyed red and green. Some of the finest ivories produced in India towards the end of the nineteenth century and during the present century were carved from the larger and finer-textured tusks imported from East Africa.

Ivory chess sets were made in India in endless variety throughout the nineteenth century, greatly differing in size, character and quality. Chesspieces were either carved or turned, or in some cases turned before being decorated by carvers. Superb sets were produced in such centres as Delhi and Madras, while some of smaller size, exhibiting more restrained ornamentation, were made in Bengal. As the majority of chess sets produced in India during the nineteenth century were intended expressly for export they were on the whole less ornate in appearance; they were made from Indian elephant ivory, except for exceptionally fine commissioned sets, carved from specially

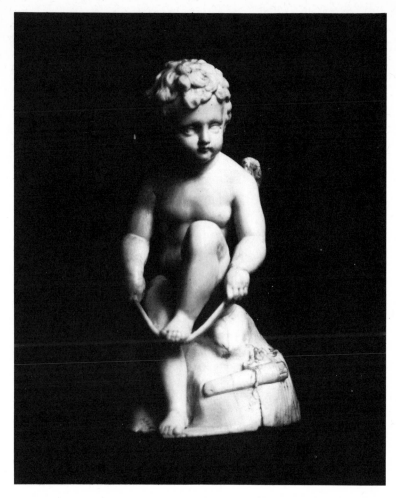

Cupid breaking his bow –
statuette by Richard Cockle
Lucas. English (nineteenth cen-
tury).

imported African ivory. The cheaper sets, produced in quantity
on a commercial basis, are not particularly outstanding in any
way though as a rule the workmanship is of surprisingly good
standard. Pieces used on opposing sides were left in natural
colour or painted crimson.

Chinese Ivories for the West

The Chinese export trade in ivory chess sets expanded as rapidly
during the nineteenth century as India's. Ivory carvers centred in
Canton began making chess sets for export to Europe in the late
eighteenth century, using Indian ivory. There is little variation in
the design of export sets made in Canton but those from the near-
by Portuguese colony of Macao exhibit more character, with
pleasing variation in shape and ornamentation. Variety in Can-
tonese sets made for the European market was usually achieved
by the use of different types of mounts. Octagonal bases were oc-

casionally featured in sets of superior quality, the base and the figure being carved from one piece of ivory. The well-known Cantonese ball-mounted chess sets, with the pieces mounted upon a carved circular base supporting a pierced concentric ball, were exported to Europe in thousands and it is surprising that more of them are not seen nowadays in western antique and curio shops. They became immensely popular with Europeans, the early nineteenth-century productions being well carved and finished, but later in the century the standard of craftsmanship declined: ball-mounted Cantonese ivory chess sets made after about 1850 have considerably less interest for collectors who appreciate fine carving: the early sets display diminutive representations of animals, birds, insects and flowers executed with amazing delicacy.

As in India, ivory carvers in China produced chess sets with the pieces portraying characters involved in the Napoleonic struggle in Europe. Rarer sets portray Chinese warriors opposing an English king and his army. Other sets include well-carved pieces mounted on rosettes or standing on flat bases devoid of carving, the figure and base cut from a single piece of ivory. Although less spectacular than ball-mounted sets, the earlier versions of these were mostly made with remarkable precision and balance, representing Chinese craftsmanship at its best.

Ivory has been carved in Canton for some three hundred years, and its trade in pieces made specially to appeal to Western taste was enormous during the nineteenth century, despite rivalry from other Chinese centres. Objects designed for foreigners were, however, usually inferior; Chinese patrons were always highly demanding, and carvers who worked for them were expected to produce faultless pieces of a character and beauty that European customers were rarely privileged to see.

While Canton prospered and expanded, eventually becoming the second great ivory-carving centre of China, the finest Chinese ivories were produced in the imperial capital, Peking, over a long period. Peking became famed for its exquisite tinted ivories. Under the patronage of successive emperors until the fall of the Ch'ing dynasty in 1912, the ivory-carving workshops of Peking remained pre-eminent in the production of ivory objects in styles dictated by court fashion. After the end of imperial rule these workshops inevitably declined, producing little that was outstanding. Instead, they concentrated on the export trade or made ivory objects that sold readily to foreigners living in Peking and the treaty ports. Peking's ivory industry has survived revolution and wars, but its future cannot be predicted.

After the opening of the Chinese treaty ports in 1842 Foochow earned a reputation for ivory production, carvers with exceptional talent creating objects of outstanding artistic merit, in-

cluding miniature temples, pagodas and houses; richly carved models of boats were also a Foochow speciality. By the close of the nineteenth century the industry had virtually become defunct, however, a short-lived revival occurring during the 1930s. Foochow's place was taken by Shanghai, the thriving international trading centre, large-scale manufacturers produced articles of everyday use, such as chopsticks and combs, in ivory. Ningpo was long famed for fine inlaid work in ivory, chiefly in the embellishment of redwood furniture, but the industry became defunct in the 1920s. At Wenchow, carvers specialised in the production of charming ivory genre groups and figures portraying peasants at work. Some Wenchow ivory groups and figures were carved with exceptional skill and collectors who acquire authentic examples should count themselves fortunate.

Hong Kong benefited when the outbreak of the Sino-Japanese war in 1937 caused many accomplished ivory carvers to flee from Canton to the safety of the British Crown Colony. The refugees opened up new workshops and within a few years Hong Kong became the centre of a thriving industry. Cantonese ivory carvers continued to work in their ancient native traditions. Since the end of World War II ivories of exceptional quality have issued from Hong Kong workshops.

On the Chinese mainland, principally in Kwangtung province, ivory carving has been encouraged by the new regime in so far that state-sponsored workshops have been established where skilled craftsmen who have inherited Ch'ing artistic traditions are permitted to produce fine ornamental objects, as well as items of everyday use; the bulk of them are exported. Thus ivory carving has not been altogether eliminated as have some other artistic occupations in present-day China. A naturally artistic race with a deeply-rooted culture and innate love of beauty, the Chinese will surely not completely abandon their heritage of art and accomplishment.

Japanese Netsukes

The most fascinating Japanese carved ivory objects are old *netsukes*. A genuine *netsuke* is an ornament once attached to, and made to be worn on, a man's costume during the Tokugawa period. It served as a kind of toggle at the top end of the cord passing under the sash from which hung the tobacco pouch, pipe and keys, or an *inro*, the Japanese portable medicine chest. *Netsukes* had to be made in correct dimension and shape to fulfil their intended purpose. At first wooden *netsukes* were made in great number, but gradually the majority were carved in ivory. Naturally, until 1868 when Japan emerged as a modern state and men began adopting the western mode of dress, all *netsukes* made were authentic specimens, made for use with native costume. In

97

An enchanting *netsuke* of Jo and Uba

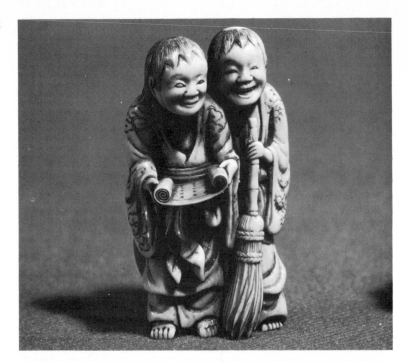

Larger and more individual than *netsukes, okimonos* were family treasures. This one shows a group of no less than five *samurai* in full armour, although only two are visible in the picture

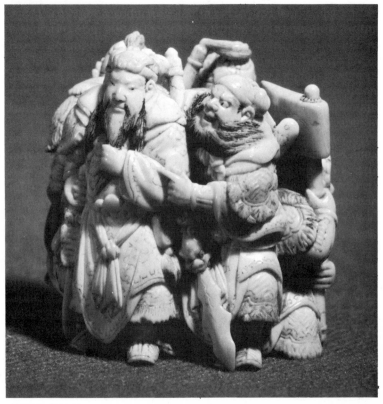

Two very different *netsukes*
show the immense variety of the
ornamental use of ivory . . .

. . . as does this *netsuke* frog

the later nineteenth century, when foreign visitors to Japan and western collectors discovered the charm and fascination of *netsukes*, expanding systematic reproduction of old examples and outright forgery caused a flood of spurious ones to appear on the market.

A *netsuke* not specifically made as an appendage of costume, which in effect means a *netsuke* actually worn and showing signs of rubbing through the friction of the cord to which it was once attached, can hardly be regarded as a genuine example. Readers are referred to the comments on spurious *netsukes* in the chapter

The Three Graces with Cupid – relief by Richard Cockle Lucas. English (nineteenth century).

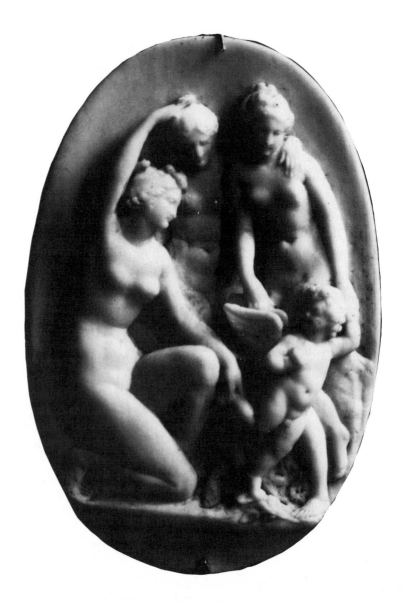

on deception and forgery, where some practical advice on distinguishing between genuinely old *netsukes* and modern fakes is given.

Celebrated carvers of *netsukes* won great esteem in Japan. The artist Shunzan, working at Nara at the end of the eighteenth century and for some time after, and Miwa I, belonging to an earlier generation of Nara carvers, were artists in wood who endowed the *netsuke* with the form from which the techniques and styles of later carvers of ivory *netsukes* evolved. Schools of *netsuke* carvers in ivory were established at Kyoto and Yedo, where in the early stages of development artists derived inspiration from the works of Miwa II and Miwa III, both supremely talented ivory carvers working at Nara who became famous for their beautiful *netsukes*. The Miwas also taught brilliant pupils, including Ikko and Gamboun, who became renowned for the high quality of their work. Most *netsukes* were produced in an age of intense artistic appreciation when time was not too pressing for the Japanese artist to take all the hours and days, even months, necessary for the completion of a masterpiece, be it an exquisitely carved *netsuke* for a nobleman's court robe, a portable altar for private devotions or an alcove ornament.

Some artists had their own styles of *netsuke* carving; for instance, Masanao became noted for his fowls, Ikkuan for his mice, Tadatoshi for his snails and Masamati for his rabbits. Some became accomplished in the execution of a single design and produced *netsuke* that were constantly repetitive in form. Others who had no skill or interest in depicting animals found inspiration in old prints by masters such as Hokusia. The great artists worked only in the finest materials, using ivory rich in tone and silky-smooth to the touch, that after the passage of time has now acquired that distinctive mellow sheen which the connoisseur looks for.

Many years ago, E. Anderson, a connoisseur of Japanese art, defined the essence of the *netsuke*: 'The designs of the netsuke carvers embrace the whole range of Japanese motives, and the artist tells his story with the utmost lucidity. Nothing is safe from his humour, except, perhaps, the official powers that be, of whom the Japanese carver has a salutary dread. Religion, history, folk-lore, novels, incidents of daily life, all provide material for his tools, and his subjects are mostly treated in a comic or even flippant vein . . . The netsuke was created from almost any object upon which the eye of the artist dwelt; the gods and the philosophers, scenes of history and the comical side of life, were present to the imagination, and therefore treated more in accord with acknowledged conventions; but in the flower and the plant, the bird, insect and reptile, what the eye saw, the willing skilful fingers translated and glorified with a patience passing belief,

with no regard for time or money, with a success that astonishes us still. Six months, a year, what did that matter? The work would be finished in due time, for there was no shirking, only a devoted perseverance.'

The art of the *netsuke* may become the study of a lifetime. Any collector who proposes to specialise in collecting Japanese ivory *netsukes* would do well to learn all he can on the subject before beginning. A great deal has been written about *netsukes*, yet much remains to be explained and discovered.

In this brief survey of the ivory art of Japan, *okimonos* must not be omitted. These are household ornaments carved in ivory which were placed with the family treasures displayed in alcoves. Usually made from elephant ivory, they took the form of small figures realistically carved with the greatest attention to details. *Okimonos* are larger than *netsukes*, and from their sizes and designs are scarcely likely to be mistaken for them. Artists lavished their utmost skill in the creation of *okimonos*, which became family heirlooms. The fact that no two are alike enhances their attraction. But the Japanese have always jealously guarded their household gods, with the result that genuine *okimonos* are in far less plentiful supply on the market than *netsukes*.

As Japan pressed forward with an expanding export trade, ivory carvers naturally became increasingly interested in producing wares for sale in European and American markets. Within a few years the workshops were turning out a steady flow of ivory card-cases, jewel caskets, jewellery, chess sets, figures, buttons and a great variety of ornaments and utilitarian items. Ivory wares were not simply beautifully carved, but many were also somewhat over-elaborately embellished with painted designs in lacquer employing a technique derived from painting on tortoiseshell originated in Osaka or Nagasaki.

Machine tools gradually came into use and the art of ivory carving in Japan rapidly declined. By the end of the first decade of the twentieth century little remained of its characteristic originality in design; it had become mainly slavish imitation and monotonous repetition. Craftsmen retained their skills, and many scorned to use other than traditional tools for hand cutting and shaping ivory, but even so they appeared to lack the inherent originality which distinguished the work of earlier Japanese ivory carvers and can be seen in varying degree in all fine Japanese ivories executed before 1900.

Art of the Eskimo

On the American continent, the Eskimos probably preserve the oldest traditions in ivory carving, their art probably going back at least a thousand years – long before Europeans arrived to bring about vital changes in their way of life. In ancient times Eskimos

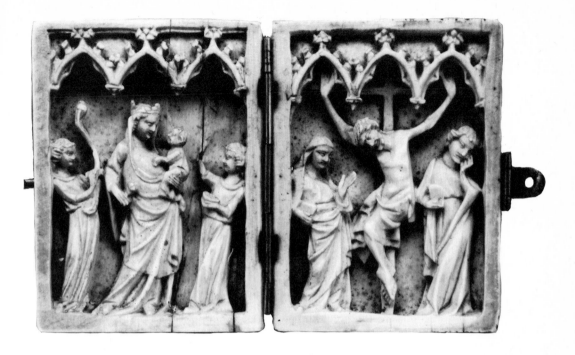

Diptych. Flemish (mid
nineteenth century).

carved bone, and also made extensive use of walrus ivory, car-
ving it into runners for sleds, hunting weapons, boat fittings, per-
sonal and household ornaments and even toys.

Eskimo carved decoration on ivory objects is invariably simple
and direct in style, executed with characteristic precision
whatever the nature of the object embellished. Engraved pictures
depicted men and animals involved in the hunt. Also featured
were small single embossed figures and geometrical patterns
composed of circles. Almost everything carved from ivory by
Eskimos was decorated, although the design might be extremely
simple. Among the most interesting items are tubular tobacco,
snuff and needle cases that Eskimos made and decorated with
great skill.

Most examples available to collectors will not date farther
back than the beginning of the nineteenth century, and well
preserved and authenticated pieces even of those are not easily
come by. Perhaps the most fascinating objects are ivory needle
cases in the form of a hollow cylinder containing a sealskin thong
holding copper or bone needles. Some very elaborate examples
have survived, many realistically carved in animal forms. Animal
sculpture in ivory is particularly associated with the Eskimos of
Alaska who developed remarkable skill in carving needle cases
from walrus ivory, although their work was surpassed by the In-
dian craftsmen who dwelt in the north-west coastal area of

103

North America. Indian carvings in walrus ivory rank among the finest examples of ivory art produced in America.

Eskimos inhabiting Greenland, the Labrador coast and north-eastern Canada have carved walrus ivory from as far back as their history can be traced, but many changes have taken place in the character of their work. With the opening-up and development of Arctic regions since the early nineteenth century, the Eskimo inhabitants have been strongly influenced in their general way of life by European culture and customs. Both in Labrador and Greenland there are at present groups of Eskimo ivory carvers who produce quite pleasing ivories from walrus tusks, although their designs are regrettably no longer traditional but devised to appeal to European customers. Government help in encouraging Eskimo artistic pursuits has progressed in Greenland as far as the establishment of training centres where the development of artistic skills is fostered and Eskimo artists are trained in modern ivory-carving techniques including the use of machine tools.

In Alaska, where Eskimo ivory carving has always been superior to that of the Eskimos in other Arctic areas, the twentieth century has brought into being a group of craftsmen in ivory who are engaged on a full-time basis to produce ivory objects suitable for the tourist trade and for export. Difficulty was experienced in the beginning in persuading them to forsake tradition, but many of the wares they produced did not appeal to American or European tastes, despite their excellent workmanship. Later, under guidance and training by Europeans and Americans, the Eskimos learned to make ivory wares that began to sell, not only locally to tourists but also in world markets.

Some of the most beautiful ivories produced in Alaska have been carved from what is commonly known as 'beach' ivory — fossilised mammoth tusks dug up from the ice along the frozen Arctic shore. The attractive mottled colouring much admired by many collectors is created by the darkening of the ivory whilst in contact over a long period with minerals in the soil. Huge quantities of fossilised mammoth ivory have been recovered from frozen river banks in northern Russia. Fossilised mammoth ivory usually differs little in appearance from ivory obtained from a freshly-killed elephant and it can generally be worked as easily.

Ivories in America

As early as at the beginning of the eighteenth century, America did not lack for ivory carvers who had emigrated from the Old World and practised their craft in the developing cities along the Atlantic seaboard. By the nineteenth century ivories of excellent quality made in the United States could be procured. On the

whole, American ivory workers preferred to make utilitarian ivory objects, with the exception of statuettes inspired by antique originals, which were popular and considered elegant ornaments for luxurious, stylish homes.

An artistic pastime particularly associated with the United States is that of 'scrimshawing', a nautical term of obscure origin. Scrimshaw – the spelling is sometimes varied – was practised by sailors during the long periods at sea and consisted of engraving and carving designs on whalebone, whale's teeth, shells and walrus tusks. The term is also sometimes applied generally to small articles made by sailors while at sea. American whaling vessels were often away from their home port for two or three years at a stretch and the men found plenty of opportunity between periods of hard work to use their jack knives or other tools in carving, Designs on a whale's tooth were engraved with a knife or some other sharp pointed implement, occasionally a sail needle, with the incised lines usually coloured black, sometimes red. As a rule, decoration was of nautical character, including ships, sea battles and whaling scenes, but it was not un-usual to depict sweethearts, sprays or baskets of flowers, harbour scenes and coats of arms. For some obscure reason the Irish harp was popular in scrimshaw.

Items of American association are the most interesting to scrimshaw collectors, though sailors of other nationalities must have made similar objects. It is thought that scrimshaw was prac-tised at sea in the late eighteenth century, but the collector has lit-tle chance of finding examples that can be safely dated earlier than 1830 and few genuine examples are of later date than about 1850. The most sought-after scrimshaw items are decorated with the Stars and Stripes, and the collector who acquires an authentic example with a named vessel depicted has secured a prize indeed. Dated pieces are discovered only seldom. Of all antique objects of American origin or association now avidly sought by collec-tors in the United States, probably scrimshaw-decorated articles depicting American whalers, the Stars and Stripes and dated are the most extensively faked.

African Ivories

African ivory art has its roots in the remote past. Possibly the culture of ancient Egypt spread roots into far-off African regions to the south and west. But, as few African tribes can trace back their history more than a few centuries, the extent of Egyptian influence can only be surmised. The Hamitic races of North Africa preserved an ancient culture that was undoubtedly an offshoot of Egyptian civilisation. Southwards from Egypt, in the Sudan and beyond, influxes of foreign settlers at successive periods brought new cultural influences, the intermingling

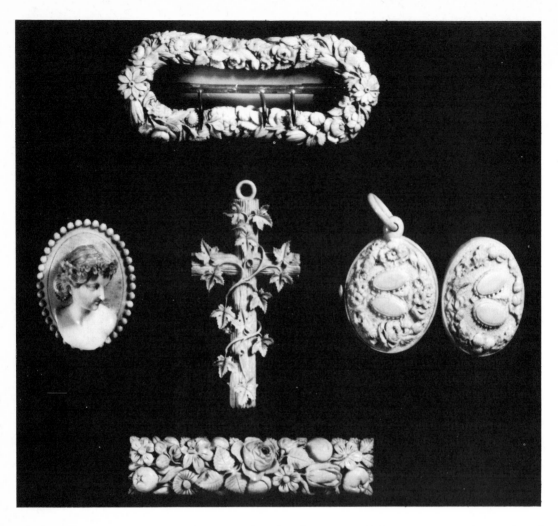

Jewellery and buckles. English and French mid nineteenth century).

resulting in the development of distinctive art forms found nowhere else. This is particularly true of West Africa where for centuries tribes have had the inherent skill to create a unique range of objects. Ivory obtained from the elephant, which was indigenous to the region, was never so widely used as wood, but in certain tribes it was selected for the carving of masks and figures.

At one time, mainly in the nineteenth century when Africa was being opened up by Europeans, African carvings in wood and ivory were regarded as merely novel, if they were not summarily rejected as ugly and unutterably crude. In the nineteenth century and even in the early decades of the twentieth century only a few collectors, rather dubiously, acquired examples as curiosities. Scarcely anyone would then have ventured to describe African sculptural art as beautiful. Opinion has

dramatically changed over the years with increasing understanding and perception. It is now recognised that African carved works in wood or ivory represent more than a jumble of weirdly carved masks and ill-conceived, eccentric and repellent figures.

There is no doubt that for its rich variety and artistic excellence the sculptural art of Nigeria is of primary importance, and Benin and Ife were the ancient principal art centres where brilliant techniques and art forms evolved, their artistic merit unsurpassed elsewhere south of the Sahara. One of the surprises and unfailing delights in the study of African sculptural art is the discovery for the first time of the amazing exuberant art of Benin, developed by inherently skilful carvers and bronze casters. Carving of ivory attained a remarkably high level of craftsanship, shown by the comparatively few examples that have survived. Among the most outstanding characteristics of Benin sculpture was its dramatic expressive realism. It has not escaped the notice of scholars and collectors that the later art of Benin is indubitably of European Renaissance derivation, due no doubt to the presence of Portuguese traders in the area. For about three centuries, until the arrival of the British in Benin in 1897 on a punitive expedition, Benin art continued subject to European influences.

Among outstanding examples of Benin ivory carving are enormous elephant tusks decorated with geometrical designs or with genre scenes and military subjects. Carved ivory masks, unsurpassed in craftsmanship and striking character, are splendid objects, invariably arresting and sometimes fearsome in the realism. These are much admired and coveted by collectors who will readily pay enormous sums for the examples occasionally offered at auction. Other objects carved in ivory by Benin artists include spoons, cups, coffers and different types of figures, some in the round, which may have had ritual significance or were of symbolic character. Carving in ivory in traditional form continued in Benin until the last years of the nineteenth century. When European and American collectors became aware of the beauty of Benin ivories, demand for them steadily increased and an attempt was made to revive production, but with little success. Ivory is still being carved in Nigeria by craftsmen who adhere to ancient traditions but the finest ivory carving in Africa today rarely exhibits the brilliant technique developed by Benin ivory carvers.

Other African tribes specialised in ivory carving. In the Cameroons ivory figurines representing pregnant women were given to women hoping to become pregnant to carry as talismans. Guardian or fetish figures of traditional type, known as *mikishi mihashi*, were produced by specially appointed artists belonging to the Luba tribe. *Mikishi mihashi* figures were ancestor

images containing individual imprisoned spirits with power to protect. They are carved boldly and realistically, especially the features, with both male and female in frontal representation. Sometimes only a torso was featured. Ivory *mikishi mihashi* figurines are not usually more than four inches high. They were protective memorial objects worn on the shoulder or attached to the belt.

A large amount of ivory carving was and still is being executed by numerous tribes inhabiting the Congo region, both along the upper and lower reaches of the river. Among the most highly skilled are the Mangbetu ivory workers who produce a great variety of ivory objects. Mangbetu sculptural art is traditional, but no fine old Mangbetu ivories survive, due to the ancient custom of burning each king's possessions after his death. The ivory figures usually represent people with elongated heads, it having been the custom in the tribe to bind the heads of infants in order to make them grow tall and pointed, this being considered beautiful.

As in past centuries, modern African negro artists excel in sculpture in various media. The collector of small ivories will be wise to consider acquiring examples of fine work in a field that is relatively new and unexploited, with the prospect of making finds which although not antique are objects of beauty that will certainly appreciate in value. It is from the tribal art of the past that many modern African sculptors draw inspiration. The day of the fetish has gone, but figures are being made today in the style of old ancestor images. Purely negroid elements in carving add interest to and enhance the often striking beauty of ivory sculpture that is now issuing from Africa and being avidly snapped up by collectors.

Collecting Modern Ivories

Ivory objects made in Europe and Asia during the nineteenth century, and even interesting good quality ivories by twentieth-century craftsmen, present the most favourable opportunity for a collector of moderate means, or less, to assemble a collection not too limited in scope or lacking investment potential. Naturally, the finest items of character belonging to any period or school will always command high prices. By principally interesting himself in nineteenth-century ivories that are less than masterpieces, and therefore will not attract the wealthy collectors, while keeping a sharp look-out and cultivating a sound sense of judgement, he will find articles not too difficult to procure at a reasonable cost. Nor should the collector overlook the interest, attraction and investment potential of good quality ivories produced in different parts of the world including Europe, Asia, America and Africa, at the end of the nineteenth century or even

during the twentieth. As the present century grows old it should be borne in mind that ivories produced in its early decades, up to the outbreak of World War II, have now mellowed and are becoming of increasing interest. Moreover, fine craftsmanship in ivory has not utterly lapsed, nor is the quality of fine elephant ivory less than it was in the past ages, though it may not be so readily procured and is vastly more costly today. There are artists active in the world today who are capable of producing exquisite ivories that will bear comparison with antique examples, except that the indefinable charm of age is missing, that unique mellow softness and sheen that the faker tries hard to reproduce with a varying measure of success.

Nineteenth-century Continental and English ivory jewellery presents an interesting collecting field, particularly for women who may enjoy wearing their acquisitions. All Victorian jewellery has rapidly increased in value during the past two decades due to demand, ivory items being no exception. Much old ivory jewellery is unfortunately incomplete or damaged in some way. Where defects are trivial, say a broken clasp or chain link, they can usually be remedied by a good repairer without serious detriment to the piece. If the item is obtainable at a satisfactory price, allowing for the cost of repairs, the collector need feel no qualms concerning purchase. But ivory jewellery that is incomplete or seriously impaired is best left alone.

English, French and German ivory chess sets carved in the nineteenth century are rapidly rising in value, and the average collector is unlikely to be able to afford them. Where cost is not a vital consideration the acquisition of a fine old ivory chess set can bring lasting pleasure, for most European, and also Asian, sets are highly ornamental and look very attractive on display. Collectors interested in carved ivory chessmen as examples of craftsmanship will not be so desirous of acquiring complete sets. Quite often odd chessmen may be discovered in curio shops and purchased for modest sums. Collectors with limited funds who are interested in chesspieces should consider assembling a 'harlequin' collection of ivory chessmen from various periods.

Indian ivories were once abundant in Britain, and collectors will not normally experience difficulty in finding examples even if they have become less common. Prices will naturally vary according to the age and quality of the items. Whether the quest for Indian ivories begins in London, Paris, New York, or anywhere else in the world, the best places to look for bargains at the start are small antique and curio shops.

It is vital for the collector to know what he is about when buying Indian ivories, as some pieces are far from being as old as the seller would have the buyer believe; moreover quality varies tremendously. A large proportion of Indian ivories are very in-

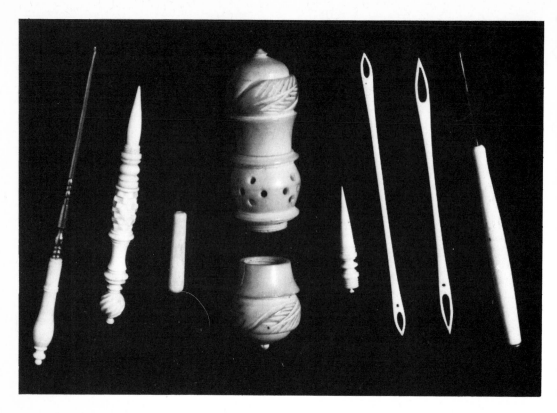

Sewing accessories, including bone tatting needles. English (mid nineteenth century).

ferior in craftsmanship. During the late nineteenth and early twentieth centuries, workshops throughout India were kept busy producing the sort of items that western taste demanded, to be distributed through export channels. Even the New World received large consignments of ivories from India. Also, discerning American collectors who visited India carried home with them some of the many fine quality Indian ivories that are in the United States today.

Nineteenth-century Indian ivory carvers assiduously copied ancient works. Very often it is only the colour of the ivory and occasional stylistic or technical errors that enable experts to distinguish between originals and reproductions. Therefore, whenever what are described as ancient Indian ivories are offered for sale the collector should act warily to avoid acquiring a nineteenth-century copy.

Chinese ivories cover an enormous range from very ancient, splendid examples, magnificent works by master carvers, down to quite trivial ivory objects made during the present century which may nevertheless be admired for their dexterous workmanship and occasionally novel character. The latter will have little interest for the serious collector, but some excellent works in ivory have been executed by modern Chinese carvers

and if any can be procured for a reasonable figure the collector would be wise not to reject them out of hand. One day the best of modern Chinese ivories will be sought and acquired by collectors for their undoubted beauty and interest.

As Chinese ivories are well distributed throughout the world the collector stands a good chance of finding pieces that appeal to him wherever he may happen to be. As the art of ivory carving has developed in China from the remote past there is much to choose from as regards period and quality. Acquisition is again largely a matter of opportunity. To secure bargains it may be necessary to wait patiently.

With Japanese ivories the position is somewhat different. Those produced during Japan's remote early phase are exceedingly rare, so the collector must not expect to come across examples of Japanese ivory carving dated much earlier than the late eighteenth century. Japanese ivories dated prior to 1800 have become very scarce too, and for the most part extremely costly. But efforts to acquire examples of Japanese work of nineteenth or early twentieth-century date will almost certainly be rewarded.

Netsukes are fascinating objects but as they are now being collected all over the world prices are constantly rising even for inferior examples. Many spurious *netsukes*, only a few years or decades old, are now circulating, passed off as authentic specimens and too readily acquired by the unwary. It should be kept in mind that the Japanese are the cleverest copyists on earth and incredible skill is displayed by modern ivory carvers in the art of faking *netsukes*.

The field of African art offers an immensely varied and fascinating opportunity to collectors. Anyone who admires African art, ivories in particular, could derive pleasure and ultimately profit from assembling a collection. It is improbable that other than comparatively modern examples of African ivory carving will be procurable by the collector with modest means as the prices obtained for outstanding examples of ancient African fine art are nowadays prodigious. But some quite attractive, competently carved African ivory objects are now reaching western markets. Since achieving independence a number of African states have encouraged native arts and crafts, including ivory carving, and there has been a steady flow of African art objects to Europe and America. Ivories are being produced in African workshops which are strikingly different in character from those carved elsewhere in the world, and are for that reason worthy of the collector's attention. Grotesque figures and such like will not invariably appeal to art lovers with more conventional tastes, but as the fine art of Africa becomes better understood its qualities and significance will be increasingly appreciated.

Those who decide to confine themselves to ivories of the nineteenth century or later, putting good craftsmanship and the charm of a piece before age and rarity, when financial considerations exclude older, more valuable objects, need not feel at too great a disadvantage. They will collect in the most varied and extensive field. Later nineteenth-century art in ivory was not totally decadent, and the collector who perseveres will be able to discover treasures among uglier objects best rejected.

8 Deception and Forgeries

Fortunately for the collector who cannot afford to spend large sums on ivories, only rare and ancient works have in general attracted the interest of the forger. The skilled ivory carver setting out deliberately to deceive by cunning imitation has not considered it worth the effort and time required to produce any but 'masterpieces' calculated to realise large sums. The collector who is not looking for ivories of other than fairly ordinary character and no great age, will by continual exercise of caution escape being taken in; it is the over-enthusiastic collector with ample funds who falls victim. The collector interested in acquiring coveted rarities for which he is prepared to pay large sums must take all possible precautions to ensure that a piece being acquired is precisely what it is stated to be.

Considering the superior skill necessary in the creation of faked works of art, for the successful forger must possess great talent and have a sound working knowledge of old techniques, many people wonder why such pains are taken to produce mere imitations. It is an odd fact that the faker is rarely inventive. Clever and resourceful he may be, but he can only exercise his skill through imitating the works of other artists.

When a demand for Gothic ivories exceeded supply during the nineteenth century the forgers took advantage of the situation and flooded the market with fakes. As one authority has put it, so great was the volume of spurious Gothic ivories available that the task of the experts became simply to find authentic items among the mass of forgeries. Many of these pseudo-Gothic ivories continue to circulate and sometimes prove dangerously tempting to collectors who can afford the outrageously high prices often asked for them by well-intentioned dealers who should know better but who have made only a cursory examination. The production of entirely faked ivories is not the only activity that can worry the inexpert collector. Restoration of ivories, that is to say the making up of incomplete or damaged pieces, is work on which unscrupulous artists have lavished amazing trickery. Unwitting acquisition of an ivory that has been subjected to re-carving, or even made up from separate pieces joined together, is a pitfall the collector should try to avoid. Today, examination of works of art under ultra-violet rays has made it possible for outright forgery and concealed restoration to be detected. The fluorescence of old and new ivory differs. Old ivory appears slightly mottled and

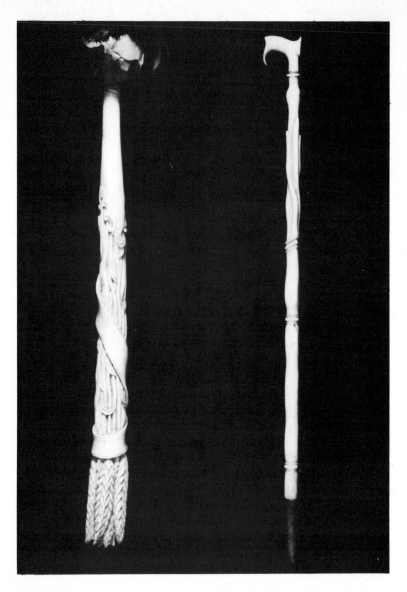

dull yellow, and new ivory appears bright yellow. Thus, a
deliberately deceptive combination of original work and later
additions can be discovered.

A collector should never too readily allow a damaged ivory to
be restored, however great the skill and reputation of the artist
prepared to undertake the work. It may be desirable to clean the
surface of the ivory by scraping off the grime of ages in order to
reveal the mellow beauty of the material, but the process
sometimes proves damaging and consequently reduces the attrac-
tion and value of a piece. Furthermore, a collector should rarely
if ever agree to have an ivory of somewhat mediocre quality 'im-

114

proved' by additional carving – as, incredible as it may appear, is sometimes done. Let the object remain as it came from the artist's workshop, or at least as its passage through the years has left it, the surface maybe roughened, the cracks and stains clearly visible, with no attempt at concealment. Of course like an old house, a painting or a piece of furniture, ivories sometimes need proper attention if their beauty is to be preserved, but such work is not of questionable nature.

The collector of ivories needs to train his eye to observe many points when judging an item. It is of the utmost importance to study the colour and texture of the various types of ivory and to become familiar with the appearance of the material when freshly worked, or after say ten, fifty, a hundred, or perhaps three hundred years. Where ivory has not been subjected to extremes of temperature or exposed to strong light, even over long periods change may be so slight as to be scarcely perceptible. Where it has been left exposed to varying temperatures, affected by atmosphere, or subjected to rough treatment, change of tone and general appearance may occur within a comparatively short time.

General statements concerning colour and condition of antique ivories can be misleading, and what is stated here is merely intended to indicate the problems and pitfalls. Expertise can only be developed through time and experience, but with interest in the subject and the will to learn almost everyone can become an expert. There is no infallible general rule for recognising the genuine or detecting the spurious. Excepting ivories that are only a few years old, perhaps, to establish with any certainty the age and provenance of ivories is invariably difficult. Authorities have never agreed on the age and provenance of numerous well-known ivories in the great museums of the world. Artistic and technical excellence are naturally always discernible when embodied in an antique ivory, but with so much copying in progress in east and west through the ages, and overlapping or revival of styles, correct attribution is often at best uncertain. Nor can colour alone be taken as a pointer to age, since as has been stated several factors may speed or slow down changes in the tone of ivory. Moreover, the forger makes cunning use of chemical treatments in order to give his productions an aged appearance and surely most people interested in ivories are aware that the colour of a piece can be darkened to simulate age by boiling or steeping in tea leaves or coffee grains! Judgement must in many cases be based upon observation in the absence of incontestable evidence.

Apart from scrutinising an object for signs of re-carving or concealed repairs, make sure that design and ornamentation tally with the style and alleged period of the piece. Forgers can be ex-

traordinarily fallible in small points such as using a motif entirely out of character or post-dating the work in question. Carvers in east and west, of whatever schools, countries and periods, worked in their individual ways, and their productions usually show recognised characteristics or techniques that sometimes forgers have failed to emulate, to their ultimate undoing.

Trivial mistakes have cost forgers dear, but some of them have kept experts guessing and arguing over their amazing copies for years on end. In Belgium, where a considerable amount of forgery in ivory carving has gone on from time to time, the activities of a ring of forgers were brought to light by someone noting a slight defect in an 'old' ivory. The reproduction Hispano-Arabic ivory caskets that issued from the Valencia workshop of D. Fransisco Pallas y Puig (1859-1926) were not intended originally to deceive but were remarkable, honestly conceived and executed works inspired by ancient prototypes. After passing through the hands of successive owners the caskets became accepted as authentic specimens of old Hispano-Arabic ivory work. Pallas also produced other ivories, all so finely executed in exact imitation of authentic Moorish work that for a long time even the greatest experts failed to observe the slight

Purse. English (mid nineteenth century).

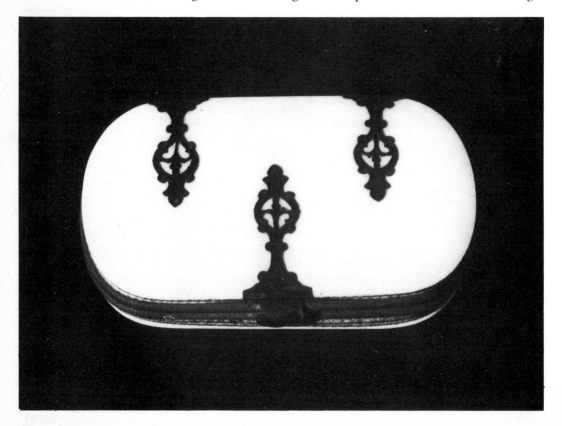

errors in style and ornament that revealed his personal touch and eventually led to exposure. It is believed that a number of as yet unrecognised Pallas ivories, accepted as authentic ancient works, are still exhibited in museums.

The Italian master ivory carver Francesco Siepi was responsible in modern times for an audacious forgery, his so-called 'Dagger of the Malatestas'. The dagger is an outstanding object which despite its deceptive character is deservingly recognised as a masterpiece executed in the highest tradition of Italian ivory carving. Siepi was a master, though lacking originality, and the beautifully carved ivory handle and sheath, the latter richly embellished with carved portraits of Sigismondo and Isotta Malatesta, are worthy to be placed among the finest productions of modern Italian master carvers in ivory.

Oriental ivories have long been imitated by forgers. In the case of Chinese ivories it is perhaps natural that forgers have largely devoted their efforts to producing deceptive copies of early works. Ming ivory statuettes have been copied by forgers active both inside and outside China. Other Chinese masterpieces in ivory have also been faithfully copied in the past, and have inspired work in the same style, so that even reproductions have now grown old and mellowed, and are only with difficulty recognised as imitative work even by experts. Many Chinese ivory carvers at work in Peking, Canton and other centres during the nineteenth century extensively copied works of early masters or worked in their style, which obliges the collector to be on his guard when purchasing Chinese ivories that are undoubtedly old, but not as old and original as he may be led to believe. The colour of the ivory, the surface texture, and particularly the manner in which the material is treated by the artist, technically and artistically, are the only sure guide to correct attribution. By study, comparison of examples, observation of styles and techniques, and not least by intuition which develops and matures as knowledge and interest deepens, the collector gains an awareness which is almost a sixth sense.

Chinese ivories of the twentieth century are largely imitative in character, inspired by early prototypes. The collector should experience no difficulty in recognising modern works. For the most part, Chinese ivories of the past fifty years or so are well executed, but they seldom exhibit the remarkable carving ability that distinguishes the works of the old masters. The carving has obviously been done with less concern for detail and effect, as though the artist could not afford the unlimited time and patience that his predecessor allowed for the production of a single masterpiece. In China since the fall of the Manchus, as elsewhere, few artists have been able to follow their creative bent with a total disregard for the time needed to finish a complex work.

Where Japanese ivory *netsukes* are concerned, we have already seen that those specially manufactured are almost always inferior to the early ones made for the adornment of native costume and a practical purpose. The collector should not find it difficult to distinguish between modern and old specimens. Sharp edges on a *netsuke*, the absence of signs of wearing by the cord around the sides of holes, the absence of the rich milky tone in the ivory that is bestowed by time, are all certain indications.

Nor is a signature on the base a guarantee of authenticity or age, that a *netsuke* was not worn and is not old. As J.F. Blacker writes in *The A.B.C. of Japanese Art*: 'The collector will perforce be compelled to rely upon his own judgement in the collection of netsukes, and again the watchword, caution, must be linked with another – handle all you can. In no branch of curios is the necessity for handling more obvious than in this, where the best book cannot indicate the points which demonstrate age as effectively as can the careful inspection of genuine old pieces and comparison between them and others. Look for colour, look for signs of wear, look for careful yet bold design and execution, and at the beginning limit yourself to the price you are prepared to pay for the lessons which experience only can teach.'

To conclude, a few words on the subject of bone, which having for thousands of years been carved in the same way as ivory, which it superficially resembles, sometimes deceives the inexperienced collector. Bone, and occasionally old carved boxwood, can be very deceptive and baffling, but there are in fact some well-defined distinguishing characteristics. First, the creamy, mellow tone of true ivory is invariably absent from bone, which will usually be either densely white or distinctly yellow. Second, the surface of bone never acquires the rich sheen of polished ivory. Third, bone can easily be recognised by the absence of the 'grain' or marking present in elephant ivory. Bone is much more difficult to carve than ivory, the outside being extremely hard while the inner core is spongy and therefore useless to the artist. As its dense surface reduces its malleability, carvers are unable to work bone freely to produce fine detailed carving. Also, large carved bone ornaments, figures, etc, will not come the way of the collector, for the simple reason that carvers have not found it possible to cut bone into good-sized pieces for carving.

9 Display and Preservation

Having assembled a collection of ivories, probably after considerable effort and expense, or even after acquiring a first ivory, a collector will naturally be interested in finding the most practical and safest means of displaying and preserving it.

Whether to place ivories within a cabinet where none may disturb them, or to distribute them through the house at points of vantage where they may be most easily seen and appreciated, is a matter of personal choice and responsibility. As ivories will not usually break if knocked over or roughly handled, as will occur with china and glass (though ivories carved with delicate open work can be very fragile), some pieces can be put on open shelves, mantelpieces or furniture without fear of disaster. Nevertheless, certain precautions are advisable to avoid their deterioration or even possible ruination.

Ivory is an exceptionally durable material, but it is very susceptible to excessive cold and heat, and is affected by damp. Extremes of temperature cause old ivory to discolour and crack. These are vital reasons why valuable old ivories should be kept in rooms, or in display cases or cabinets, where even temperatures can be maintained. Radiators, open fires, the cold of unused rooms, can all threaten the condition of ivories. It is as inadvisable to expose them to bright sunlight for long periods as to shut them away in dark rooms or cupboards, as either way changes in colour may be induced.

Do not attempt too hastily to scrape the surface of old ivories, which is really a matter for a qualified restorer when it is decided that it must be done. Before resorting to more drastic treatment, try cleaning ivories with water to which a little detergent has been added; some authorities maintain that only soapy water can be used with absolute safety. Use water very sparingly and never more than lukewarm. Dry the object thoroughly immediately after washing. Ivory, particularly Asian ivory, yellows naturally in the process of age and it is wiser not to attempt bleaching at the risk of damaging the surface.

If an ivory is so badly stained as to appear unsightly, gentle dabbing with a soft cloth moistened with methylated spirit mixed with water may improve the appearance – but avoid hard rubbing. Apart from stains gathered through time as a result of use and handling, a considerable proportion of old ivories – especially Chinese – were burnt-stained or artificially coloured by means

Benin carved elephant tusk, detailed section (nineteenth century).

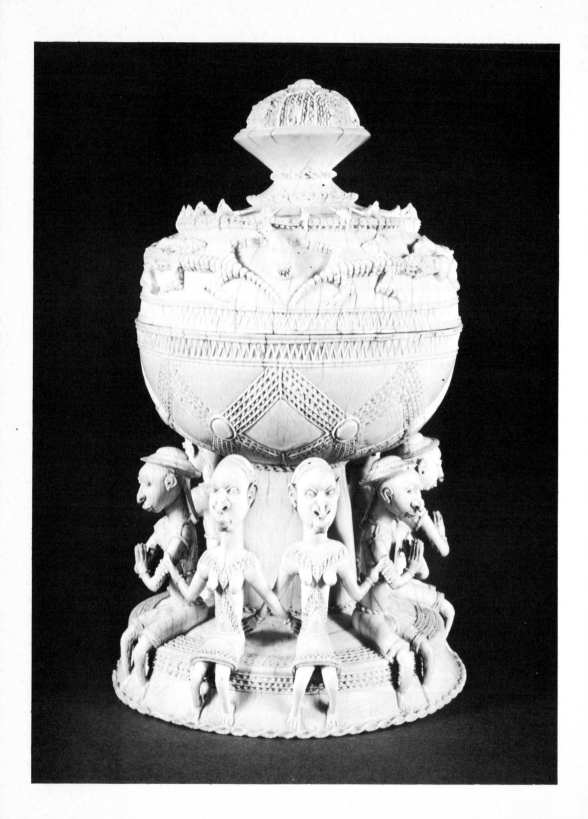

of various processes. A collector who has acquired an ivory that shows signs of staining or colouring is advised to ascertain before treatment that he is not removing original stain or pigment.

A last word on display. It is a pleasure to take ivories from their place of safety within a cabinet and to set them where their beauty can be better seen. The owner of a growing collection can do this while simultaneously ensuring that his treasures are not over-exposed to strong light and extremes of temperature by occasionally changing the objects displayed around a room or altering their position.

Opposite: European function, African flair and energy: a massive ivory salt cellar, relic of Portuguese colonial rule

Bibliography

(Selected works listed in order of publication)

The Ivory Workers of the Middle Ages. *A. M. Cust. London, 1902*

Elfenbein Plastik Seit Der Renaissance. *C. Scherer. Leipzig, 1902*

Primitive Art in Egypt. *J. Capont. London, 1905*

Catalogue of the Ivory Carvings of the Christian Era in the British Museum. *O. M. Dalton, 1909*

Netsuke. *A. Brockhaus. Leipzig, 1909*

Arts and Crafts of India and Ceylon. *A. K. Coomaraswamy. London, 1913*

Les Ivoires Gothiques Francais. *R. Koechlin. Paris, 1924*

Ivory in China. *B. Laufer. Chicago, 1925*

English Ivories. *M. H. Longhurst. London, 1926*

Early Engraved Ivories. *Hispanic Society of America. New York, 1928*

Die Byzantin Elfenbein Skulpturen. *A. G. Goldschmidt and K. Weitzmann. Leipzig, 1930-34*

Early Ivories from Samaria. *J. W. and G. M. Crowfoot. London, 1938*

Siculo-Arabic Ivories. *P. B. Cott. Princeton, 1939*

Chinese Ivory Sculpture. *W. E. Cox. New York, 1946*

Gothic Ivories of the 13th and 14th Centuries. *J. Natanson. London, 1951*

Early Christian Ivories. *J. Natanson. London, 1957*

Ivories. *R. A. Burnett. London, 1957*

Afro-Portugese Ivories. *W. B. Fagg and W. Forman. London, 1959*

Netsuke: A Miniature Art of Japan. *Y. Okada. 4th edn. Tokyo, 1960*

Simon Troger und Andere Elfenbein Kunstler aus Tirol. *E. Philippowich. Innsbruck, 1961*

Japanese Decorative Art. *M. Feddersen. New York, 1962*

Ivory. *C. Beigbeder. London, 1965*

Ivory. *Geoffrey Wills. London, 1968*

Acknowledgements

While engaged on this work I was privileged to inspect a number of privately owned collections of ivories, which enabled me to obtain valuable information that is incorporated in the book. I am grateful to the collectors who willingly allowed me access to their ivories.

The following museum officials were extremely helpful in a number of ways, not the least important being their assistance in obtaining suitable photographs. Their advice and help in problems connected with special photography is appreciated Virginia Pow, Assistant Keeper, Department of Art, City Museum & Art Gallery, Birmingham: Brian J.R. Blench, Keeper of Decorative Arts, and Helen C. Adamson, Assistant Keeper of Archaeology, Ethnography & History, Glasgow Art Gallery & Museum Graham Teasdill, Curator, Russell-Cotes Art Gallery & Museum and the Rothesay Museum, Bournemouth: A.R. Mountford, City Museum & Art Gallery, Stoke-on-Trent: staff members of the Victoria & Albert Museum and British Museum, London.

I am indebted to Hugh de S. Shortt, Curator of the Salisbury & South Wiltshire Museum for patiently answering my many questions, for arranging on my behalf to have photographs specially taken of a number of interesting ivories in the museum, and other favours.

John Van Haeften of Messrs Christie's cordially rendered me timely assistance for which I am grateful.

For permission to quote from Arthur Thomson's *Biology for Everyman* thanks are expressed to Messrs J.M. Dent & Sons Ltd, London, and E.P. Dutton & Co Inc, New York.

Photographs are reproduced by permission of the following authorities: *Page 10, 13, 32, 39, 55, 58, 110, 114, 116* – Salisbury & South Wiltshire Museum; *17, 21, 25, 81, 85* – Messrs Christie, Manson & Woods, London; *28, 45, 95, 100* – Victoria & Albert Museum; *36, 48, 51, 74* – H. Morris & Bournemouth Museums; *40* – Victoria & Albert Museum/Michael Holford Library; *99* – Victoria & Albert Museum/Cooper Bridgeman; *41* – Hessesches Landmuseum, Darmstadt/Cooper Bridgeman; *61, 65, 68, 77* – City Museum & Art Gallery, Stoke-on-Trent; *69* – Kabul Museum/Michael Holford Library; *70, 120* – British Museum/Michael Holford Library; *98* – British Museum/Cooper Bridgeman; *91, 103, 106* – Birmingham Museum & Art Gallery; *119* – Glasgow Art Gallery & Museum; *99* (top) – Douglas Wright & R. Todd-White/Cooper Bridgeman *Front jacket:* H. Morris & Bournemouth Museums *Back Jacket and Frontispiece:* Messrs Christie, Manson & Woods, London.

Index